THE LAST CARAVAGGIO

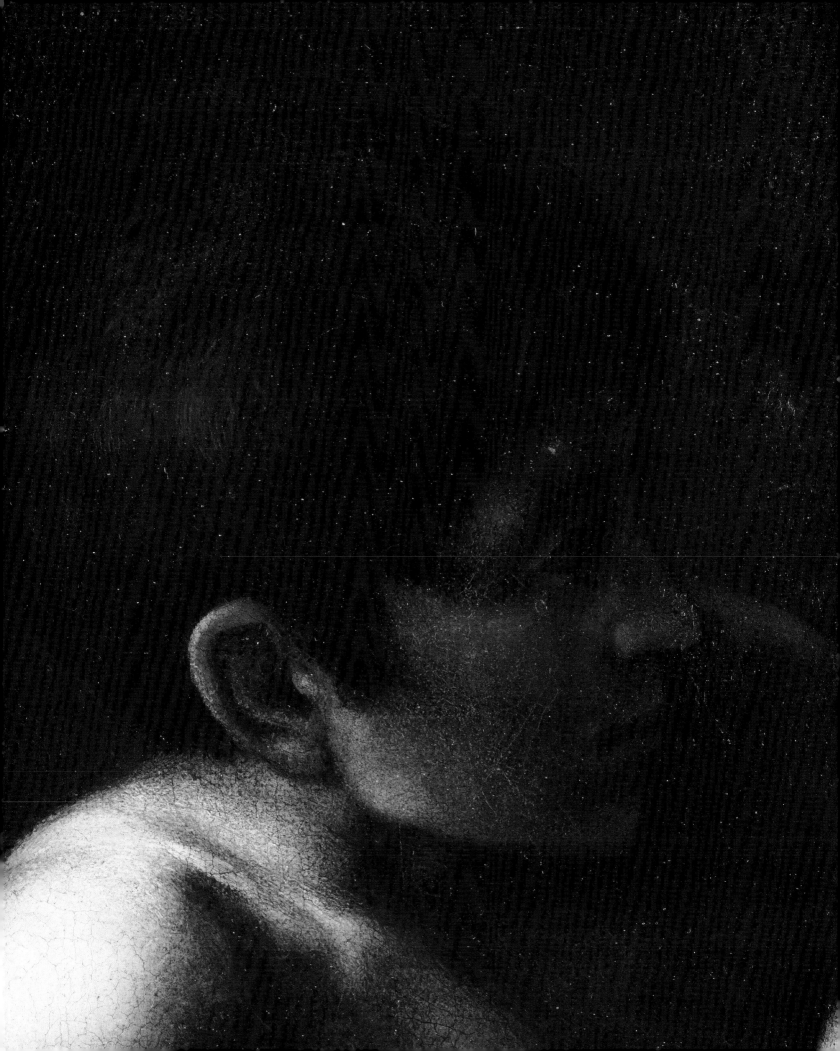

The last
Caravaggio

Editing Bert Treffers & Guus van den Hout

UITGEVERIJ WAANDERS, ZWOLLE
MUSEUM HET REMBRANDTHUIS, AMSTERDAM
GUUS VAN DEN HOUT ART & ADVICE, AMSTERDAM

CONTENTS

One of the very first biographers of Caravaggio is the Dutch biographer of artists Karel van Mander (1548-1606). In his *Doorlughtighe Italiaensche Schilders* (Illustrious Italian Painters) from 1603 he criticizes the painter who is doing remarkable things Rome, but, van Mander says, is not dedicated enough to his art and does not do his best. After working for a fortnight he becomes a pub-loafer for months. Everywhere he goes, he carries a dagger. He is always followed by a servant. Every tennis-courts is his. Always and everywhere he is looking for quarrels. On the whole, he is best avoided altogether.

The original text has the allure of a picaresque novel. The description is soon to be seen as the key not only to the person of the painter himself, but also to his work. there is an exotically modern ring to the words of van Mander.

Caravaggio doesn't study enough, and everybody sees 'dat hy niet stadigh hem ter studie en begheeft' so he writes (in the Dutch of his time) and continues: 'maer hebbende een veerthien daghen ghewrocht gaet hy der twee oft een maendt tegehn wandelen met 't Rapier op't sijde met een knecht achter hem van d'een Kaetsbaen in d'ander seer gheneghen tot vechten en krackeelen wesende soo dat het seldsaem met hem om te gaen is'.

In 2006 the Rembrandt – Caravaggio exhibition brought 440.000 visitors to the Van Gogh Museum in Amsterdam. For the first time, the public was able to see important work by Caravaggio in a Dutch Museum and judge for themselves how much these relate to the major work by Rembrandt. Ever since, the interest in the Italian master has steadily increased. Both artists are part of the absolute elite and have exercised a strong influence on the development of the history of western art. Also, their turbulent personal lives stimulate our imagination. Artistically speaking they are each others match and related to one another by their work process. The realistic painting style and the special way of handling light and dark in Caravaggio are coming back with Rembrandt, even though the latter uses his own language. Both are seen as the two great geniuses within the art of Baroque Painting in the south and the north of Europe.

Almost five years later, just within the year in which we commemorate the death of the Italian painter in deplorable circumstances 400 years ago, an important painting of Caravaggio can be admired in Amsterdam: *John the Baptist reclining*. Not just any work but the painting that many experts consider his last ever creation, dated 1610; a painting that, furthermore, has never before been publicly exhibited. It makes me extra proud that the owner of this remarkable work of art has chosen Museum het Rembrandthuis to show it for the first time to the world. In the unique setting of Rembrandt's former studio, this painting will be shown to the public for two months. It is a unique opportunity that will not be repeated. I thank the owner of the painting for his generosity towards the museum. I sincerely thank Bert Treffers, an outstanding connoisseur of Caravaggio, who has brought this project about and has taken the scientific coordination of it upon himself. He is also responsible for two fascinating articles in this publication.

 We were also able to secure contributions from three eminent Italian experts on Caravaggio: Maurizio Marini, Claudio Strinati and Vincenzo Pacelli. In this book we also go deeper into the thorough technical research of the painting and its history over the past centuries. The publishing-firm Waanders has, in the person of Henk van de Wal, taken care of the excellent quality of the book. This publication, and its presentation in the Rembrandthuis, would not have been possible without the expertise, the dedication and the enthusiasm of Guus van den Hout, friend and colleague. In conclusion, I therefore would like to express my gratitude to him as well.

Janrense Boonstra
director Museum Het Rembrandthuis

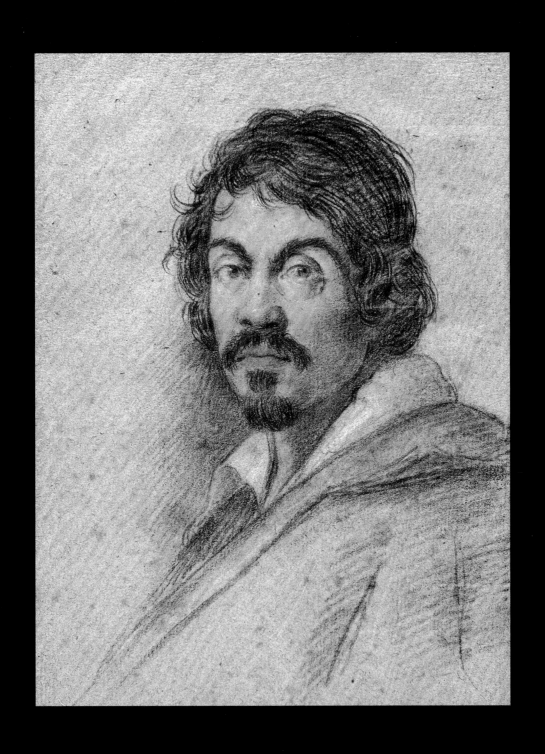

Michelangelo Merisi da Caravaggio (1571-1610). An artist between myth and reality

Bert Treffers

The interest for the Italian artist Michelangelo Merisi, (fig. 1) better known by the name of Caravaggio, has developed over the last decennia into a real *hype*. Just like with Rembrandt and Van Gogh where a multicoloured mix of facts and fiction has led to the most bizarre theories, one can in the meanwhile also for as much as the person of Caravaggio is concerned talk about the exaggerated creation of myth. Numerous drama pieces, romances and films stage him as someone far ahead of its own times. Stripped of any form of historical conscience, he becomes annexed as an artist who's art is up-to-date, because it is supposed to be the expression of his feelings and conceptions that agree rather with ours then with those of his contemporaries.

However lately it becomes growingly clear that In fact we do not know all that much about what the artist himself thought. But maybe we want too much. The forcing magic of his work might just be the fruit of his irascibility. It seems that the painter with equal ease manoeuvred the dagger as well as the brush. What we see, we recognise as the reflection of *modern* torment. His demonical sense of life lies, according to that same forming of the myth, at the basis of an art that breaks with that of his own time.

MODERN

Even just the word 'modern' is misleading. In the 17th century Giovan Pietro Bellori uses the same word in his book edited in Rome in 1672 *The lives of the modern painters, sculptors and architects.* To us the word modern means 'new' and therefore better than everything that had been before. But in the 17th century it does not imply a judgement of value. New is what is made in that very moment. The art of Rafael and Michelangelo is new exactly because it bases itself on the art of the Ancient times: the Greeks and the Romans. The only thing the artist is supposed to do is try to reach that enlightening example and maybe even to surpass it. The latter is not only a question of prettiness, or beauty but mostly a matter of effect, of rhetoric. Good art manipulates the emotions, and should the public be moved then it agrees more easily with the message and is therefore morally edified of its own accord.

Even the word public is problematic from the historical perspective. Caravaggio's contemporaries are much better introduced then we are in the contents of his work. If they don't, it is taken care of that this gap is filled. The work is carrier of a precise message. The contents determine the form. But the contemporary visitor of exhibits is not keen on being taught. He himself will decide what is good and what is bad. However he is a lot less free then he thinks. His emotional response is in many cases pre-programmed by the media and the press. Artist and work coincide. The inner sentimental life of the maker has in fact become the theme of his art while the original contents barely interests us.

In the 17th century that is different. For Bellori the contents play a crucial role. Essential is the question of what has been represented precisely and how that is done. It is all about the essence and the meaning of the work. Besides the contents are for the greater part detached from the painter. Form is the wrapping of a message that rises above the artist. Also for that reason art serves a specific goal. Even the frame within which the experience of it comes about is different from today's and is strongly determined by theological and moral value's. In the end it is about good and evil, and about truth.

The form serves to render the theme inclusive the message it contains credible. If the form is credible, then the contents are as well. Both, together are under direct control from above. There is too much at stake. The clerical and mundane authorities are carefully keeping watch that the representation of the theme does not lead to dissentient interpretations that are entirely different from the official doctrine. The form of the work forms the user as well. Should he be led to wrong ideas then the work has failed. The work does not meet its requirements and will be refused by the client. Thus it gets detached from its context and becomes an almost useless decoration. No longer does it meet a clearly defined purpose.

Time after time at the end of the 16th and the beginning of the 17th century the work of artists is being refused. It doesn't happen only to Caravaggio but even to an artist as versatile as Rubens. When the Flemish master delivers in 1608 his painting for the main altar for the church of the Oratorians of Filippo Neri, the Chiesa Nuova in Rome, they are not satisfied. However beautiful it is, it does not agree with the assignment.

But in the case of Rubens we have a fascinating exchange of letters that throw a surprising light on the reasons for the refusal by the Oratorians. All Rome comes to see the painting, writes Rubens himself, and everybody thinks it is beautiful. But then, the light falls in a wrong way on the spot for which it is destined with the result that it is barely visible. In order to save his reputation Rubens immediately makes a new version. The original composition of the altarpiece is being split up in three separate paintings: the centre altarpiece in the middle is now on both sides flanked by a painting. This intervention leads to a surprising result. The three paintings together form an almost dynamic entity creating a baroque effect. The apse of the church where the paintings still are this way becomes almost a theatre. It is not only a matter of pure formality: the new staging of the three works in their spatial context, re-

sults to be more functional not only for as much as their contents but also liturgically. The devotional experience is now stimulated stronger and steered into the right channels. The end result is such that the three paintings in their totality correspond much more to what the aim was. Beauty and rhetoric here coincide. The artistic inventiveness is completely at the service of the function that the paintings have.

Rubens is a diplomat who knows precisely how to deal with his commissioners. His letters are testimonial of a highly developed business-instinct, which he puts at service of his artistic ambitions. For as much as Caravaggio is concerned we have not even one direct personal document that permits us insight in the way he reacts when work of his is refused. There exists no handwritten letter of his. All we have is second hand. His declarations during the many juridical hearings he was forced to undergo, say everything and nothing. Even the declarations he supposedly did about his ideas regarding his own art are mainly of anecdotal value. What he thinks and feels when the first version of *The Conversion of Paul* for the Cerasi-chapel in the Santa Maria del Popolo is refused, is not known. The precise reasons why the painter radically changed the composition of *The Martyrdom of Matthew* (fig. 2) in the Contarelli-chapel of the San Luigi dei Francesi, the church of the French dedicated to the saint Louis of France in Rome, is also unknown to us. It seems that the objections have mainly to do with the way the theme is represented. The form touches the contents and it is the content that lie at the origin of the work.

The second, definite version of *The Conversion of Paul* (fig. 3) that up to today is still to be found in the Cerasi-chapel hits us as much more radical than the first. That

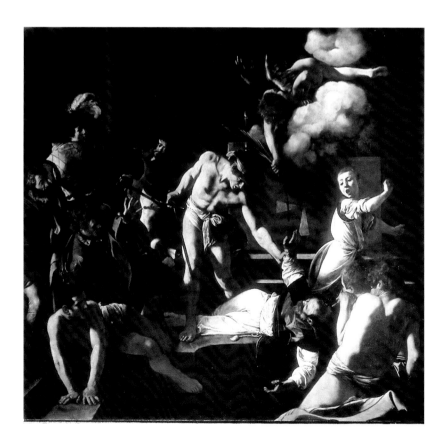

2 Caravaggio, *The Martyrdom of Matthew*, 1599-1600, Rome, San Luigi dei Francesi, Contarelli Chapel

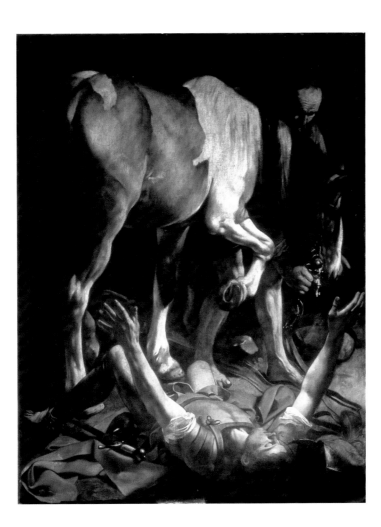

painting too must have made an enormous impression, but at the same time it provokes lots of negative criticism. On that painting nothing happens, is soon the verdict. Each form of drama is lacking. The painter is unable to tell. It is static and all action is missing.

INTERPRETATION

Now, 400 years later, it is us that determine the contents of Caravaggio's work. What we see is in our head. We don't need the pulpit. But we too see only what we hear. In 1993 Riccardo Bassani and Fiora Bellini publish a violently contested book with the title of: *Caravaggio murderer*. In this the painter is described as an *angry young man* with leftish political opinions. His presumed homosexuality makes him per definition an outsider that inevitably must have been at odds with his commissioners and that institution to which they were bound, the Church. Caravaggio, as they assert, lives at the border of existence and is therefore socially moved and from there attains his inspiration.

In the catalogue of the big Caravaggio exhibition, in Rome earlier this year, this opinion does not play a role anymore. That also leads to criticism on the exhibit. Caravaggio would now all of a sudden be used for a renovated catholic revisionism. No

longer is he the symbol of a form of contemporary libertinism. His work would therewith be annexed by that institution he precisely wanted to fight. To see him as a historical exponent of the world of then, the Papal Rome of around 1600, would be an attempt to neutralise the revolutionary character of his art.

LIFE AND WORK

It is not in the intention to describe the course of the life of Caravaggio in detail here. It has been done elsewhere for so many times, that in this place it seems almost superfluous. In the meantime we know that the painter was born on September 22, 1571 in Milan. His parents have probably moved soon after their marriage to Milan from Caravaggio for economical reasons. There it is that the painter spends his years of schooling.

The 1st of July 1592 is probably his last time in Caravaggio. Then the properties of his family are being divided. In the autumn of 1594 or 1595 the young painter is in Rome. A few years later he has his breakthrough. In 1599 he receives his first public commission and to be exact for the paintings of the Contarelli-chapel in the church of the holy Louis of France, the San Luigi de' Francesi. Immediately it was a hit: when his two paintings on both sides of the altar, the so-called *laterali,* and the first altar piece, that results to have been substituted soon after by the definitive version, are unveiled they immediately are subject of the talk of the day. On the 4th of July of the year 1600 Caravaggio receives most probably the last payment for these works. That year is a so-called holy year: all faithful that go to Rome will there receive plenary indulgence for their sins. Maybe that the great affluence of pilgrims and curious visitors has helped to spread the news about the work, considered remarkable, of this young painter, also beyond the borders of Rome. No two months later, on September 24th, 1600 Caravaggio concludes again an important contract. Here it concerns the two paintings on both sides of the altar in the burial chapel of the papal master of treasure, Tiberio Cerasi, in the Santa Maria del Popolo. In May 1601 Cerasi dies. The finishing of the chapel including both paintings of Caravaggio as well as the altarpiece of Annibale Caracci are being financed from the legacy. On November 11th, 1606 the chapel is consecrated.

However at the Contarelli-chapel as well as the Cerasi-chapel things almost went wrong. The painting on the right hand side in the Contarelli-chapel with the Martyrdom of the gospel writer Matthew must have cost the painter a lot of effort. From the x-rays it results that the definite version is strongly different from the original lay out. Evidently the painter feels forced to drastically change the depiction of this theme. That situation repeats itself in the Cerasi-chapel. Here too in both cases the definite version differs fundamentally from the first.

The work for both chapels seems, and not only for the period of their creation, strictly interwoven, which also goes for their contents. In the definite version of the Martyrdom of Matthew the gospel writer falls with both arms widely spread. The executioner has done his work. And also Paul on the painting in the Cerasi-chapel lays on the ground with his arms spread. The same motive reappears obviously on the painting on the other side with the *Crucifixion of Peter.* Mary on the altarpiece of Annibale Carracci also has her arms spread (fig 4). Matthew on the painting on the

right side in the Contarelli-chapel as well as Paul and Peter in the Cerasi-chapel thus call the faithful to *imitate* their example and to follow with word and deed Christ into death. Those that pick up the cross will be redeemed by the cross. That is the heart of the message of both chapels. The form of the definite versions leave no space for misunderstanding. The believer has to follow the saints: just like them he has to be willing to be crucified in body and soul. Those that don't get that message miss the essence of the works of Caravaggio and don't understand the virtuosity with which the painter tunes the form on the function. His art is users-art: the form manipulates the user. The nails in the hands of Peter have to be felt in his hands. He has to adopt the posture of Paul that has fallen from his horse, spread his arms and physically feel what he experiences inside. Only when the believer knows what he sees he will know what to do: that what the saint over there on the wall shows him.

CRIMINAL OR MARTYR

Over the last period the chronology of the work of Caravaggio is again being discussed. The same goes for its meaning and function. This has quite some effect on the vision we have of the private person that is the artist. By and by people get accustomed to the idea that the work has to do with the passionate spirituality of the end of the 16th century. This finds its roots in the mentality of important church reformers of that period. In particular Milan plays an important role in that to us almost fundamentalistic reforming zest.

One of the pioneers of the Caravaggio research, Maurizio Calvesi, asserts already in the seventies of the past century, that the work of Caravaggio is strictly interwoven with the Counterreformation, or rather with that movement of reformation within the Catholic Church, that after the Council of Trento which ends in 1563, took on its definite form. Crucial is the role of the archbishop of Milan, Cardinal Carlo Borromeo. In the meantime, the opinions of Calvesi have been, even if reluctantly, accepted.

This means that also the criminal carrier of the painter acquires an entirely different meaning. On May 28, 1606 it comes to manslaughter. During a game of tennis the painter wounds Ranuccio Tomassoni, who soon after dies because of his injuries. Caravaggio flees Rome and finds shelter with a powerful family with whom he, already in his younger years in Milan and Caravaggio, has an excellent relationship: the Colonna. On October 6th, 1606 he seems to be in Naples. Almost immediately he receives extremely prestigious commissions. On January 9th, 1607 he gets a payment for an altarpiece that he made for the *Pio Monte della Misericordia* (fig. 5). The work must have made a great impression because it is decided that it is never to leave the chapel. Until the day of today it is still to be found there. For the obtaining of this commission Caravaggio makes able use of his personal network. Amongst the noblemen that play an important role in the foundation of the above mentioned charitable institution is Ascanio Carafa with whom Caravaggio also keeps in touch later. The Carafa's are tied to the Colonna's.

In 1607 he goes to Malta. There for the Knights of Malta he paints one of his most monumental paintings, *The decapitation of John the Baptist* (fig. 6). On that canvas of 361 x 520 cm. the whole representation is concentrated around a small group of four people standing around the figure of the saint that lies on the ground with his hands

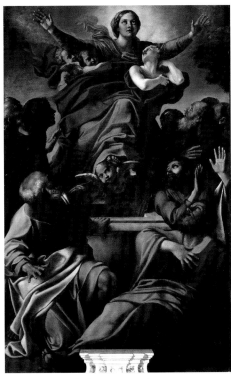

4 Annibale Carracci, *The Assumption of the Virgin*, 1601, Rome, Santa Maria del Popolo

tied to his back. The hangman has done his work. With his left hand he grabs the head by the hair. And with the other hand he keeps a knife behind his back. Is he on the point of completing his work of execution or has he already done so? One more moment and the head of John will land on the tray held up by Salome. The warder in the middle is directing all. But he doesn't do much: he just indicates the tray. In fact it is us that fill in what has happened and what still has to happen. The blood sprays on the ground. With that painted blood the artist writes his name: f. Michelangelo (fig. 7). It seems a macabre joke. But it is more then that: this way the painter mainly makes a statement: the *f* stands for fra and shows that he is a member of the Knighthood of Malta for which he makes this painting. He too is ready to give his blood for the good cause, just like the patron of the order, John the Baptist. This way blood he will be testimony of the faith. He accepts, just like his fellow knights, all consequences of the membership of the order.

15

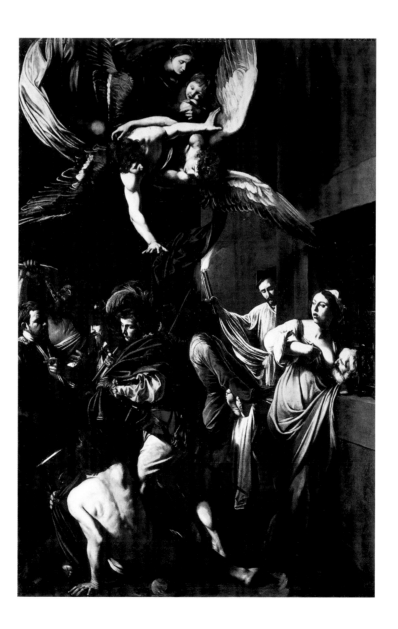

5 Caravaggio, *The Seven works of Mercy*, 1607, Napels, Pio Monte della Misericordia

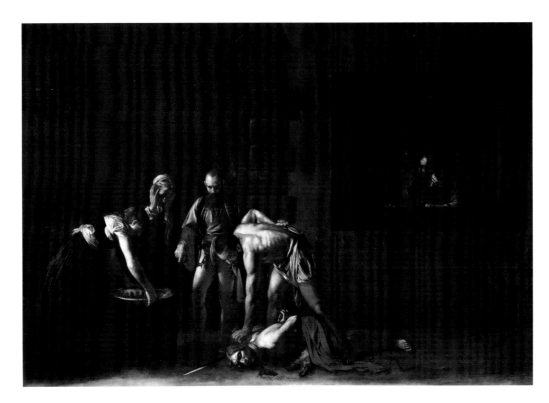

6 Caravaggio, *The Beheading of John the Baptist*, 1608, La Valetta, Oratorio di San Giovanni Battista

7 Caravaggio, *The Beheading of John the Baptist* (detail)

THE FATE

On August 18th 1608 things go wrong again. During a quarrel the painter wounds a Knight of Malta. On October 6th 1608 he flees the dungeon. Thus he sins against the rules and commits treason. He must have been helped with this, probably by Gerolamo Carafa, warder of the jail and a relative of the afore mentioned Ascanio Carafa. Gerolamo is also related to the Colonna's. Here too the circle is complete. When Caravaggio, on December 1st is officially expelled from the Order, he is already in Sicily.

His *Beheading of John the Baptist* (fig. 6) on Malta results to be criterion for everything he paints afterwards. The big size of the canvas is being used to place the figures much stronger so then before in their own space. Fiction and reality are barely dividable. The main subject is now really central. The bystanders become living witnesses that are all ready to follow the example and to draw lesson from what they see. The unity of the composition strengthens their unanimity. Should on *The Martyrdom of Matthew* (fig. 2) there have been room for deviant behaviour, there is no longer any room for that on *The Burial of Lucy*. On the Martyrdom one can still refuse the message: the man on the left spreads his arms and shows that way that he, just like the gospel writer, is not only willing to testify, but also to do so with his blood. But some of the present are still looking back. A single one flees and shows that he is not willing to take the cross. But this is seen as treason, treason to Christ, and thus treason to one self. After Malta there is only acceptance of what leads to liberation. And it seems that in the meantime also the painter himself knows that. He realises that what he paints is also important for himself. Caravaggio in that way becomes his own public.

8 Caravaggio, *John the Baptist seated*, 1610, Rome, Galleria Borghese

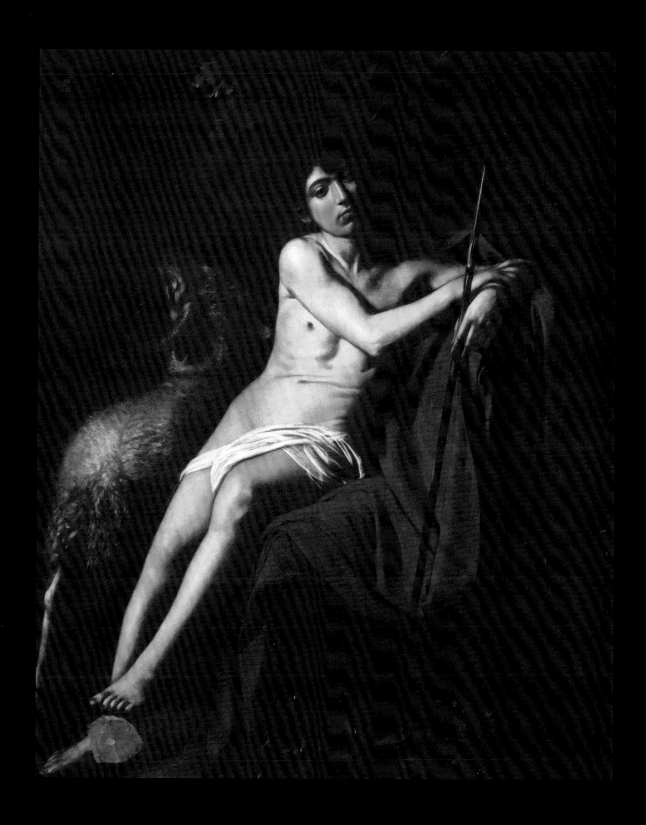

From Sicily Caravaggio returns to Naples. There on October 24th 1609 he is attacked in a pub and seriously wounded. Soon the rumour goes that he is dying. On the 10th and 11th of July 1610 he results to be on a ship to Rome. Probably he knows already that he will be pardoned for the fatal incident of 1606. At Palo, a harbour near Cerveteri, he is taken from board for a check on his papers. The ship doesn't wait for him and sails on with on board his last three paintings. Caravaggio doesn't succeed in catching up with the ship and seems doomed to loose the paintings he so bitterly needs for his survival. But that would mean to return to Rome empty handed. The three works are intended for his Roman protectors and probably serve as a sort off bribe for his already obtained grace. Maybe he is already ill and physically strongly weakened as a result from the wounds he got in Naples. On July 18th 1610 he dies near Porto Ercole. One of his fiercest opponents, Giovanni Baglione, writes in his *Descriptions of the lives of painters, sculptors and architects from the pontificate of Gregory XIII up to and including that of Urban VIII* that was published in 1642 in Rome: 'and without any human help few days after, he died, just as miserable as he lived'.

The three paintings on the boat go back to Naples. Two of the three paintings have John the Baptist for a subject. One of them in the end reached cardinal Scipione Borghese, the powerful cousin of Pope Paul V. The painting still hangs in the Galleria Borghese (fig. 8). The other canvas with John is now part of a private collection. This painting, the last the painter made (fig. 22), is the artistic testament of the painter. The third painting, a Maria Magdalena, the outstanding example of sin, repentance and penance, has probably gone lost. But by an ironic freak of fate both paintings of John the Baptist have been preserved. The saint is still indicating the road that the painter might have wanted to walk himself, but without success.

The last Caravaggio

Claudio Strinati

The *John the Baptist reclining* (fig. 22) with a dark landscape at his back has a peculiar precedent in the career of Caravaggio and that is in the *Christ on the Mount of Olives* (fig. 9). This painting, part of the collections of the Kaiser Friedrich Museum in Berlin, was destroyed in 1945 and today only known by pictures. In that grand masterpiece Caravaggio has represented the figure of Christ that bows towards one of the disciples (identified as Peter) while the other two are sleeping, unaware of what goes on. Well, the vigil and proud Peter is painted laying against the background of a landscape of a disconcerting and magnificent impact worthy of the best Caravaggio. It is incredible how in this painting the leading role is not played by Christ, who seems almost to lean towards the disciple, but by the latter in which all the representative force of the painting is concentrated. It is the only case, in the entire production of Caravaggio, of an image of a reclining figure against a landscape according to a Venetian custom going back to the roots of the art of Caravaggio.

In fact there is no doubt that Caravaggio, ever since his young years, had knowledge of the Venetian light and landscapes, which explains the sentence of Federico Zuccari, as testified by Giovanni Baglione in *Le vite dei pittori, scultori... (The lives of the painters, sculptors...)* of 1642, when he went to visit the Contarelli chapel in the church of San Luigi dei Francesi and affirmed how Caravaggio, in his work there, had been influenced, and not just a little bit, by the style of Giorgione. Whether this thesis is true or not, it is certain that representation of landscapes are rare in the painting of Caravaggio, and the idea of creating a dialogue between the figure and the landscape is even rarer. If evident in the *Christ on the Mount of Olives* (fig. 9), this figurative idea results even more accentuated in the *John the Baptist reclining*, because here, there are no other people and the painting is the ultimate expression of a great sense of loneliness, of painful interior torment, of unquiet quietness, reinforced by the landscape made of a great hilly buttress beyond which one glimpses a fading light of sunset.

Whichever iconological interpretation one wants to apply to this painting, it is absolutely evident that this is a piece of work that is born from the theme of the end and of painful remorse. The *Baptist*, a forerunner destined to a tragic death, seems to search inside himself and almost to sink into the shadow that comes rising from the back practically wiping out the physiognomy of the figure as well as the landscape

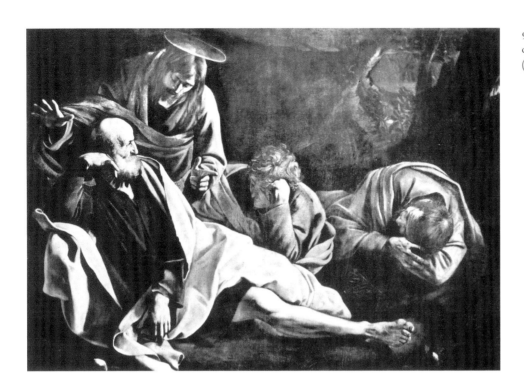

itself while great relevance is being given to the red cloak that covers the ground and marks the highest and most intense note of the painting.

It is as if Caravaggio, with this painting, returns to the experiences from his younger years full with Venetian tradition, introspection, meditation on the fate of youth and on delusions brought on by unsatisfied hopes, typical of the first age of man.

In this painting there are even memories of the delicate gradations of Leonardo, passed indeed in heritage to Giorgione and his followers, to reach Caravaggio maybe expressed differently, but without direct contradiction to what the original intent was maybe in a different way then in origin but not contradictory so.

TWO VERSIONS OF JOHN THE BAPTIST

Time and again the painting has been considered a very late work of Caravaggio, probably to be identified with one of the two paintings, both representing John the Baptist, that the master brought with him on the felucca that took him to Porto Ercole. This is a fundamental point as it gives us the possibility to bring some clarity as to the last two years of the life of Caravaggio, as well as to the production of that moment. In fact, in spite of the numerous studies regarding the last period of the master (by which we mean the period between his arrival in Naples in 1606 and his death in 1610) the reconstruction of his actual production in that period is still full of uncertainties. In this context, for instance, it is interesting to compare *John the Baptist seated* (fig. 8) from the Borghese Gallery in Rome and the *John the Baptist reclining* (fig. 22), subject of the research in this book. Both have been argued to be the Baptist from the felucca. But the abyss between these two paintings is such that we doubt they could have been made in the same moment, which supposedly coincides

with the last phases of the life of the master. Of course it is easy to object that the two paintings of the felucca both representing John the Baptist might not necessarily have been painted in the same period. Of course Caravaggio could have brought paintings with him made in different moments of his life and that, for whatever reason, had remained with him, maybe to be sold later, or to be kept.

Even so, *John the Baptist seated* of the Borghese Gallery has been considered by various exegetes exactly like a very late work of Caravaggio, if not even the last. Since the same characteristic has also been attributed to the other *John the Baptist reclining*, one must take a side in this controversy, in order to acquire a more complete knowledge about these paintings and about the last Caravaggio generally speaking.

The Borghese *John the Baptist seated* doesn't strike us as an extremely beautiful painting. Various details are badly done and somehow unpleasant, like the stocky legs of the saint, the blank expression of his face, the awkward sheep (or ram like others say) and many other small details in its surroundings, ugly and painted with neglect. However, the autography of this work has barely ever been doubted and many experts have thought that maybe Caravaggio, pressed by tragic circumstances, could have painted the last things with neglect and speed. The *John the Baptist reclining* is almost the opposite. The paint is thick and dim except for the cloak; the relation figure-landscape is realised with masterly skill; the expression of the face is pensive and profound; the grand landscape that seemingly absorbs the figure is majestic and remote, with an effect of great formal severity and absolute introspection. Would it be possible that Caravaggio within a few months, if not a few days, could have realised the same subject (even if not really the same, because the iconography of the *John the Baptist reclining* and *seated* contains substantial differences in itself) in such a different way and with results that, even concerning the quality, are quite opposite?

STYLISTIC DISCREPANCIES WITHIN THE LATE WORK OF CARAVAGGIO

To answer such a question, the papers can only help us up to a certain point, because too many certainties regarding other late paintings are lacking in order to be able to trace the road of the master in his last twenty four months of work, in a coherent and convincing way.

Much has been attributed to the last Caravaggio (as is true for the early and mature years of the artist) but taking into consideration those paintings of which the attribution of the last two years is more certain, we can observe some things that may be of help to analyse the *John the Baptist reclining*.

For a more precise outline it is better to start with the year 1608. In 1608 Caravaggio works a lot and at a high level of concentration and quality. He is in Malta and is making the memorable and beautiful portrait of *Alof de Wignacourt and his page* (fig. 10) now at the Louvre. It is a portrait both official and personal on which the commander has been conferred superior dignity and authority; but at the same time the presence of the page and the pose of the figure make him more concretely real in an everyday way and all the intelligence and humanity of the man emerge from the formidable and dense set-up, which is so typical for Caravaggio in the period of his passing between Rome and Naples two years earlier, culminating im-

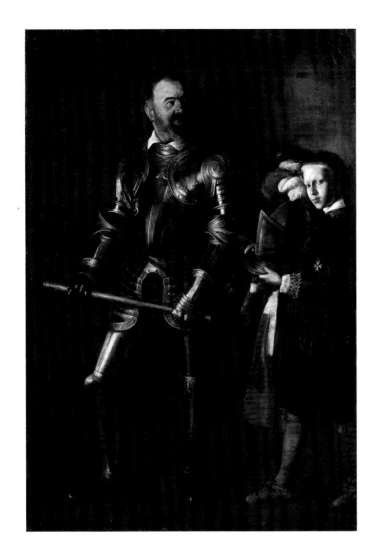

mediately in his masterwork of the *The Seven Works of Mercy* (fig. 5), in Naples. Immediately thereafter Caravaggio paints the *Jerome at his Writing Desk,* which is also a portrait of Wignacourt, during an intense and solemn moment of meditation on faith and death; another unforgettable painting, bearing that magnanimity which we see in the great masterworks of the Neapolitan period like the *Flagellation* of the Dominic church. The apotheosis arrives with *The Beheading of John the Baptist* (fig. 6) in the Oratory of the Saint John cathedral of Valletta where the creative power of Caravaggio arises to triumph. And it is not by chance that the work is signed and marked with blood, even though the space of the rough walls of the prison almost has the better over the figures themselves. It is a procedure of fantastic beauty which he uses immediately again, to create the now damaged masterwork of *The Burial of Lucy* (fig. 14) of Syracusa (in the meantime he also painted the *Sleeping Cupid* (fig. 27) now at the Galleria Palatina in Florence, this too, a work of a maximum expressive density and profoundness) where the walls of the dungeon become the real protagonists of the painting and the two jailors busy digging the grave assume gigantic proportions as though wanting to measure themselves with the immense space at their back. The people present seem to crouch away into themselves crushed by the weight of the aggressiveness of the painter. Although the *Burial* has been painted

with thick pictorial material, the state of conservation has impoverished it so much that today we are unable to fully grasp the terrible contrast the master wanted between the figures and the rough and impenetrable wall. A slight margin seems noticeable with respect to other earlier work but Caravaggio does not yield from his path.

At least three works, that do not fit well together, are datable in 1609, and they differ so much that it makes us think that modern historiography has had some difficulty in the correct reconstruction of the itinerary of Caravaggio. In fact, at the beginning of the year Caravaggio has supposedly handed over *The Raising of Lazarus* (fig. 19) in Messina, a work of very powerful invention, but tired and above all, painted in a strange and unexpected way with regard to what he had done just a little before. The material is arid and poor. The definition of the physiognomy is exalting but the quality of the set-up is not homogeneous and might seem neglected. In this case one might really think that hurry must have played a role in the creation of the painting and it is legitimate to suspect that the master has been working with still unidentified helpers. The suspicion becomes stronger looking at the painting that must have been realised right after *The Raising of Lazarus*, which is *The Adoration of the Shepherds* (fig. 26) of Messina. Here the way of setting up is very different. The elaboration is very accurate and rich of surprises, the paint is fuller and more compact, the definition of masses is more coherent even if various improprieties and some things created in haste leak through, but those are frequent in the entire parable of the master. But this painting too has items that are not homogeneous and rather strongly so. Paradoxically it is sublime in its details that could have been considered of minor relevance while criticisable in its bigger parts. Sublime is the description of the hut and sublime is the description of the animals. Here, the moral tension towards the humble revelation of reality and the great mysteries of the soul, can be found. As always in Caravaggio the depiction of the animals (in this case the ox and the donkey) reaches the apex of pure sentiment. The image of the poor wooden staves with which the hut has been built reveals the entire intimacy and beauty of the pictorial set-up of Caravaggio. The men and the women, instead, are less beautiful. The drawing is heavy, the features present some grossness of approach, the composition is repetitive, but a little mechanically so, the so typical principle of Caravaggio to enclose all figures in one sort off overhanging geometrical form unites them, but the result is a little laboured.

Even greater is our disconcert when we examine that what is supposed to be the last work of that fatal year 1609, the *Nativity* of Palermo, the painting sadly known because it has been stolen from the Oratory where it was hanging in 1969, and was never recovered. For over forty years nobody has seen this painting, and therefore the personal memory cannot deliver perfectly its terms of analysis but it is evident how the painting was again realised with the style with which Caravaggio had arrived in Naples in 1606. It is hard to draw a conclusion. It seems impossible that the master had made the painting of the *Nativity* in a previous period and then would have hung it in the Oratory of the St. Lawrence in Palermo, but the facts that one

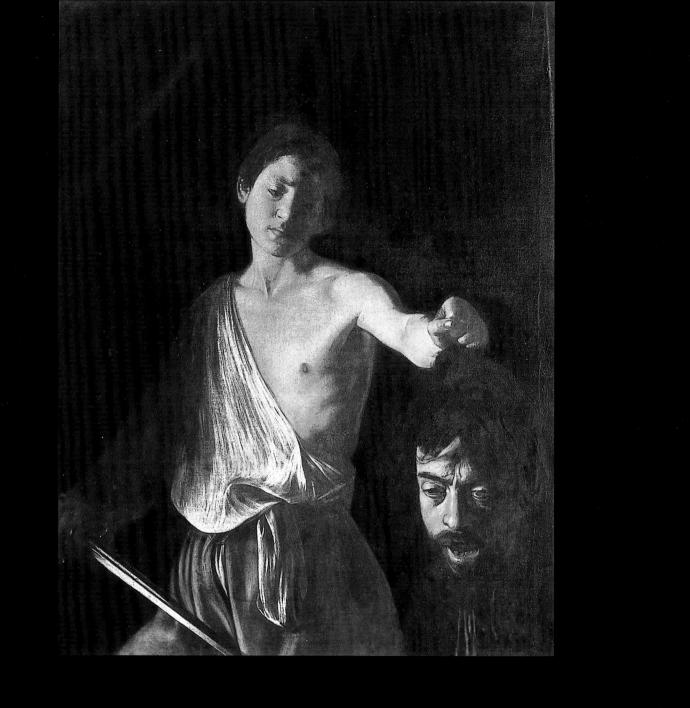

draws from attentively scrutinising the painting cause perplexity. Some of the themes typical for the Roman and earliest Neapolitan period return, like the descending angel holding the scroll ornament, visibly designed with the model lying on a couch explicitly resting on a solid surface and then soared in the air. The figures with their backs turned of whom we only see the nape return, the fullness of the set-up returns, the shining material of the paint, the fascinating contrast between light and shadow audaciously juxtaposed.

MANY QUESTIONS BUT NOT SO MANY ANSWERS

Ever since, the exegetes have questioned themselves regarding this peculiar evolution of Caravaggio in his second-last year of activity. And, obviously, here the fundamental argument jumps to attention: how to place that whole series of work that, correctly or incorrectly so, have been considered of the last period and thus related to the major works just now recalled. And, obviously, here, the crucial debate jumps to attention, namely: how to place that whole series of work that, right or wrong, have been attributed to the last period, and thus related to the major works just now recalled. For instance, what do we make of the various versions of *Young John drinking at the fountain* that Caravaggio painted as a full figure as well as half-length, in a series of paintings of which some are of excellent quality and other less important? And where, in the timeline, must we place that sublime *David and Goliath* (fig. 11) of the Borghese Gallery wherein Caravaggio paints himself in the cut off head with the swollen face? Someone did place this masterwork at the end of his production, in the late 1610, whilst others instead have related it to the consequences of the ag-

11 Caravaggio, *David and Goliath*, 1610, Rome, Galleria Borghese

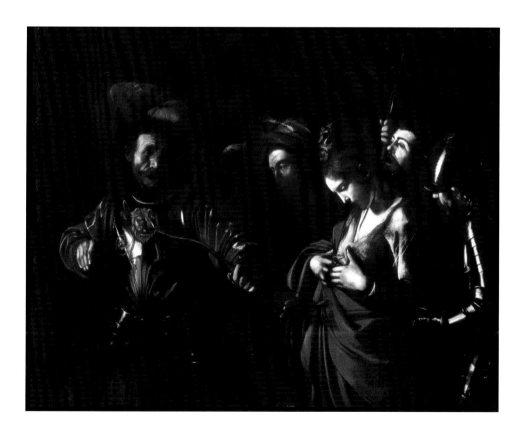

12 Caravaggio, *The Martyrdom of Ursula*, 1610, Napels, collection Banca Intesa Sanpaolo

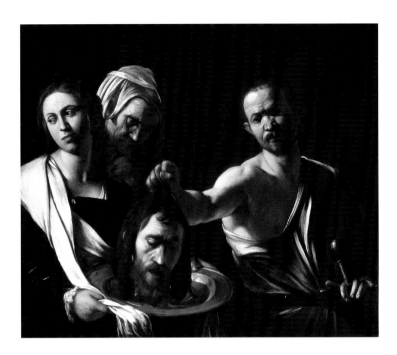

13 Caravaggio, *Salome with the head of John the Baptist*, 1609-1610, Madrid, Royal Palace

gression that Caravaggio suffered, approximately a year earlier, therefore rating the painting as a part of his 1609 series, somehow relating it to the *Nativity* of Palermo. What are we to think of the haggard *The Martyrdom of Ursula* (fig. 12)? The documents date it with certainty to 1610 but it sports a self portrait of Caravaggio identical to the one the master painted in *The Taking of Christ* (fig. 16) Mattei, dated back to 1602, when the appearance of the master must have been somewhat different than 8 years later.

Where, or rather when, to place the remarkable *Denial of Peter* of the Metropolitan Museum of Art in New York, originating from Naples, that has some things in common with *The Martyrdom of Ursula* but has a much fuller, stronger and more expressive set-up? Not to mention the gorgeous *Salome with the head of John the Baptist* (fig. 13) in the Royal Palace of Madrid, maybe datable in 1609 as well but full of the splendour deriving of the material that characterizes the older Caravaggio. Skipping, in the end, the unsolvable problem of the *Annunciation* of Nancy that might be from a lot earlier than its late dating presently sustained by many experts, but is absolutely hypothetical; aside from its disastrous state of conservation and only to be valuated in the figure of the angel, as has been verified after the last restoration by the Superior Institute for the Conservation and Restoration of Rome in occasion of the celebrative exhibit of Caravaggio in the Scuderie of the Quirinal (2010).

PLEA FOR A REVIEW OF CARAVAGGIO'S WORK

In order to be able to place the *John the Baptist reclining* (fig. 22) as precisely as possible one should be able to give concrete and exhaustive answers to this and other questions that have risen in the studies of the last fifty years with regard to the figure of the late Caravaggio.

In substance, the bases to reach a conclusion is not an integral and perfectly coherent reconstruction which is currently still not exhaustive for the last Caravaggio

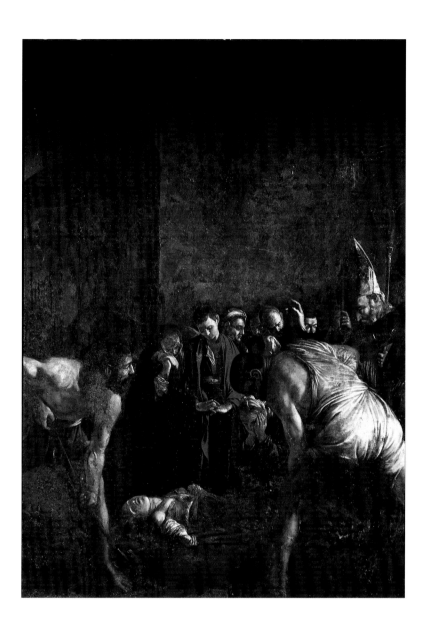

but a series of hypotheses and intuitions that are legitimate but must yet be verified during research. So the essential point is that one has to comprehend that we cannot talk about a last Caravaggio but only about the various and sometimes contradictory aspects of the last Caravaggio.

HOW DOES THE *JOHN THE BAPTIST RECLINING* FIT INTO THIS DISCUSSION?

Beyond doubt the perception of the clear tension, present in the final phase of Merisi between the moment of the evidently very strong urge to maintain his mature style, which had brought him triumph in Rome and Naples, and the openings of the last hour towards the visionary and utopian novelty that leaks through, in an imprecise and fragmentary way in some paintings that are undoubtedly dated 1609 like *The Raising of Lazarus* in Messina.

Caravaggio did not make mistakes he was most certainly probing out a different

and surprising direction. But he had only just begun to direct himself towards this 'new way' that might have taken him to a disintegration of the material and a visual synthesis in which he could reinsert some things of his juvenile formation, like his Venetian heritage that every once in a while reappears in his art, at least each time landscape is prominently involved; for instance in the memorable example of *The Conversion of Paul* Odescalchi or *The Sacrifice of Isaac* in the Uffizi.

The fact that in the *John the Baptist reclining* there is so much space dedicated to landscape makes it possible to draw a comparison with *The Burial of Lucy* (fig. 14) or *The Adoration of the Shepherds* (fig. 26) in Messina. The landscape in the *John the Baptist reclining* takes the place of the massive wall of the dungeon or the hut of *The Adoration* in Messina but in a figurative way it is exactly the same. At the same time in *John the Baptist reclining* there is still that formidable will of the master to exalt the full and powerful material of the red used for the big drapery mindful of the Roman and Neapolitan experiences.

Undoubtedly however that the suffering image of the Forerunner, almost turned towards a distance of which the end cannot be seen, fortifies the return to the moralising images of the youth of Caravaggio like those of *The Boy Peeling Fruit*, the *Boy Bitten by a Lizard*, and of *The Boy with a Vase of Roses*. They are paintings of which we know a certain number of versions but of which it is very difficult to establish the existence of the real original prototype (maybe in case of *The Boy bitten by a Lizard* this is possible with reference to the version in the National Gallery in London) but it doesn't really matter. What matters in this case is the return of the last Caravaggio to the first Caravaggio when he painted those moralising little paintings that made such an impression on his contemporaries culminating in the so called *Young Sick Bacchus* of the Borghese Gallery.

The *John the Baptist reclining* too seems to be a part of that group of young melancholic boys that meditate on the triviality of the human things and on the disillusions of young age, frustrated by the wickedness of destiny.

In that sense it is rather suggestive to think that Caravaggio in this painting wanted to summarize some of his main themes in view of the possible opening of a new phase that he never saw because of his untimely death, just like the *John the Baptist reclining* cannot see anything beyond the screen of the mountain under which he is lying and under which he seems to meditate the ultimate sense of the end.

The testament of Caravaggio:
John the Baptist reclining

Bert Treffers

For some paintings it takes a lot of time to get to the bottom of. The condition in which they are conserved doesn't always make it easy to value them. Real works of art become stronger the longer you take your time to sit down in front of them and just contemplate them. It is as though they grow in force. Those that take the trouble for once not to approach the paintings of Caravaggio from a contemporary point of view, will thus be richly rewarded.

Take the painting of *John the Baptist*, the last work of Caravaggio. Who has actually been depicted? Who is that boy? What does he do? Not much, apparently, maybe nothing at all. And then there is the myth about the sexual preferences of the painter. What Caravaggio did with his brush, he might also have done between the sheets. All those young saints are nothing else then an alibi. That *John* (fig. 15) in Kansas City is just about old enough, but that little chap here on Caravaggio's last painting from 1610, is too young and dangerous. Those that look at him don't touch him only with the eyes. That boy lives and breathes, is just body. His scarlet robe has cunningly slipped off of his shoulders. He is real, almost too real.

THE SENSE OF THE BODY

The lifelikeness of the painted body, that naturalism, serves a goal. 'When today I entered the church, I saw how in the light of a thousand torches, and in the light of thousand lamps, a child was born', thus yells the Franciscan clergyman Francesco Panigarola in a sermon he holds on the 24th of June 1576 in Bologna and that twenty years later in 1596 is printed. On that date the catholic church yearly commemorates the birth of John the Baptist. Immediately after Panigarola does something that we already have done too, 'Who do you think, who do you actually think that boy really is?' he asks rhetorically.

Those present in church already know the answer: it can only be John the Baptist. In his imagination Panigarola vests the young saint with what he knows about him and his public does the same. 'Today he is born', so continues the sermon. The image of the just born John presented as a vision is not only being materialised, but at the same time stripped of his physical presence. The rhetorical formula used by Panigarola serves to make belief that he really sees the saint here in the church, but

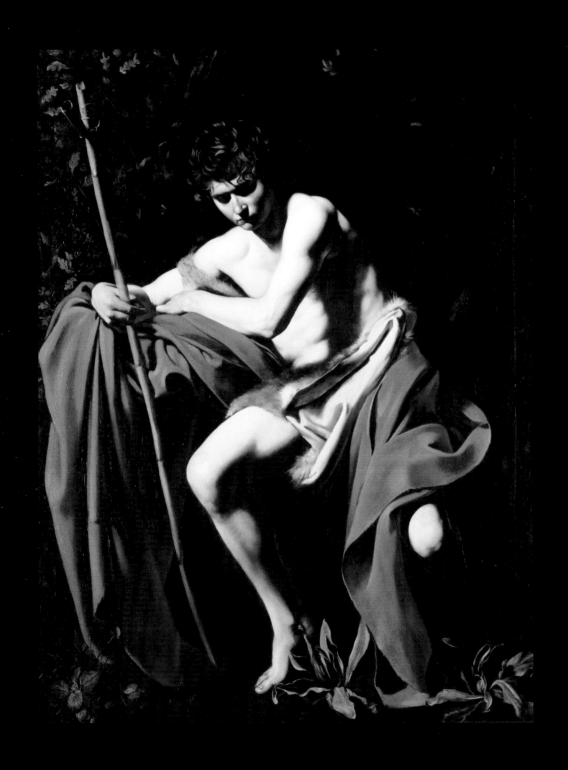

then in a vision and 'with the eyes of the spirit'. Or more stronger *cordis oculis*, with the *eyes of his hart.*

Due to him his audience sees the still young saint. The inner image becomes visible because of the rhetorical gifts of Panigarola; but that visibility becomes immediately an inner image again. The John evoked by the word gets the tangibility of a vision. Panigarola declares that he is in love with that child, that due to him everybody is seeing in imagination, and his audience falls in love with him too. Already at his birth, and even before, thus knows Panigarola, that child is testimonial to Christ. For that matter he is a guarantee for His arrival. The voice of that child will by and by get louder. All that hear him will tread in his footsteps. John shows the way. He is, like it is said in the devotional literature, a 'school' in which one learns what to do and what to leave.

PROPAGANDA

In the late 16th and 17th century an abundance of devotional literature appears. These writings aren't exactly to our liking, but all those pamphlets and books give a surprisingly good example of the way in which the believer at that time looked at things that were holy. They them to help to walk the path full of thorns to lead a morally honourable life and contain lots of learning but little pleasantry. *The book,* so writes in the middle of the 16th century the Spanish mystic Theresa from Avila, *was a consolation to me (...) my help, my companion, my shield that intercepted the many attacks of dispersive thoughts.*

Those that are unable to read, are manipulated everywhere, from the pulpit and even on the streets. Charismatic groups are hunting the streets to save souls. They are preaching with everything, with the word, with art, even with music. That music, says Filippo Neri, is the best net to catch souls with. Even Caravaggio's painting with that extremely young John the Baptist is bent on this and primary has a didactical function. The naturalism, the lifelikeness of the painted saint emphasises the seeming of his existence. He is so tangible that one cannot deny him. He offers himself and one is obliged to use him, but then in the right way. What is good and what is bad everyone can know, and if you don't the church will explain. In the end it is a matter of choice: the user will have to choose between good and evil. Only those that see the good and want it, can hope that he will end well. This dilemma is even being staged in the Year of the Jubilee 1600. The drama that each time comes about, is to be seen and heard in what sometimes is being called the first opera, the *Rappresentatione di anima, et di corpo* by Emilio de' Cavalieri. It is successfully staged in the Oratorium of Filippo Neri in Rome. The public is moved to tears.

TO FEEL WITH THE SOUL

Each time again the reflection and the experience happened within this pattern that had been handed down for ages. The writer of the *Mistici Senesi* a book that has been written at the beginning of the past century and that has seen numerous reprints, Pietro Misciattelli, condenses it in a paraphrase of the words of the holy Catherine of Siena as follows: *the feeling that comes after the mind, loves and becomes united with what the minds' eye sees. 'One has to raise above one self'* is one of the saints' expressions, and

still from Catherine of Siena: *One has to arm oneself with one's own sensibility*. In the Rome of the Counterreformation this long tradition is still up to date. Of course at that time too one preferably ended up in the gutter. God forbid that it really got that far, and no means will be left untried to avoid it. The at the time dominant fundamentalism of which practically the entire society is drenched is described in a moving way by Jean Delumeau that has been given the menacing title of: 'The sin and the fear. The thought of guilt in the West from the 13th up and including the 18th century'. It appeared some quarter of a century ago, in Paris and has been reprinted quite a few times.

It is the church-father Augustine that remarks that daily life was a peculiar mixture of *Babylon and Sion, between earth and heaven*. But in that everyday's Babylon one has to discover the road to Sion. Doom and redemption are interwoven in a magical way. Who has seen that once, sees by himself that it is better to flee the world. Forewarned is forearmed. Who sins is ready for hell, and lies fallow for salvation. Only when he sees that the world is a desert, he can learn to see paradise in the desert. Only when the heart is brushed empty of the evil, there will be room for the Lord. That is what John understands ever since his childhood. That is the reason why, writes Calcagnini from Genoa in a book that saw the light in 1648, the saint, still extremely young, is being called: *an inhabitant of the woods, and of the mountains. He had no other company that the grace of heaven, so one had to believe that he spent all his time in prayer, in contemplation, with a full heart, only feeling, and in conversation with God.*

The Word of God grows with the reader, wrote Gregory the Great around the year 600. Caravaggio painted John more or less eight times and each time as a growing boy. Only in Malta he isn't, but that has to do with the place and the function of the painting.

Theologians for that matter frankly admit, that there isn't really that much knowledge about John. The suspect is that he leaves the world very young and that he only comes out around his thirties with the baptism of Christ. It is however common thinking that one knows what he has done between his boyhood and his thirtieth year of life. He will have fasted a lot and that way have prepared himself for the coming of the Messiah. He becomes older, and that growth takes place in his mind as well. Those first steps on his road are easy to follow with the help of the paintings of Caravaggio. Once he turned thirty John's inner ripening is so much that he can preach and baptise. After the baptism of Christ he will testify with his blood that he has seen the word he has proclaimed all that time also in the flesh.

THE LAST JOHN OF CARAVAGGIO

The painting of Caravaggio gives little information (fig. 22). But what at first seems just boring, soon develops into a mysterious atmosphere of expectation. The boy is just lying about. But now we know who he is, we perceive details, the shifting play of light and shadow that governs the space of view. The figure, at a first glance a young, earthly and mortal boy, results to be an acquaintance. The few details become the building stones of a story we know already. We remember what we have always known. Also for that reason the painting does not only become functional, but

effective too. The form becomes substance, the substance gets form. Every detail gets sense and meaning. Our knowledge makes us susceptible to subtly evocated *suspense.* The Jesuit Athanasius Kirchner measures around 1650 the force of what he considers good music, by the degree in which it strikes and transports its audience. They will be totally taken. That also goes for the visual arts. But there and in particular in the case of Caravaggio, that procedure only starts when the painting stops. It is the upbeat for the story that the onlooker completes. Only when the saint starts living within us, he does what he is supposed to do. When that young John grows within us, we grow with him.

Even just the size of the canvas contributes to the impression that the depicted figure is in the same space as we are. His desert becomes ours. It is not clear where he lies: does le lie in front of a grotto, or is it a rocky site, desolate, bare, just as bare as the boy that lies there. He admits us into his atmosphere, into his world. His lack of action becomes a form of expectation. That feeling masters us and sets us in tension. John sees something that at first we barely notice, but that now grace to him we see too: the light of his daybreak glimmers now for us too. It isn't much yet, it doesn't have much power yet, but even so it is there. And it works. That still feeble ex-

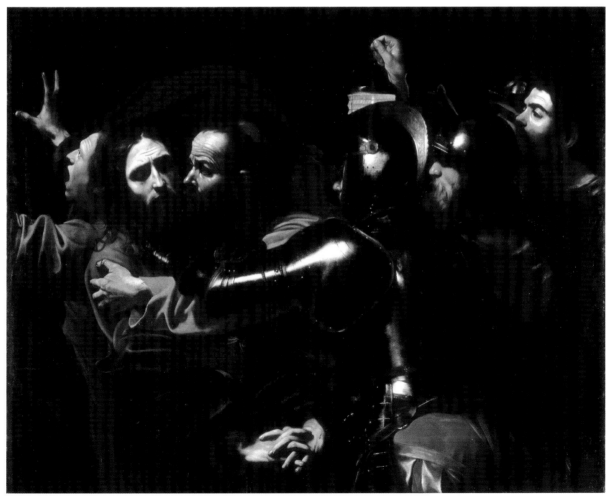

16 Caravaggio, *The Taking of Christ*, 1602, Dublin, National Gallery of Ireland

pectance does touch us as well. John is still lying in the dark, for a moment and then he will be illuminated by that shine of which we also know that it will become stronger and stronger. That light is the forerunner of what is to come: the one and only real and true light, Christ. The body of John gets in the mysterious game of light and darkness not only form, but also volume. Who makes the effort to look for a longer time will feel how he grows into someone that is tangibly near.

EMOTION

The magic of the paintings of Caravaggio does not lie in the reproduction of human feelings, the so called *affetti*. That doesn't mean that they are lacking. In reality the figures by him depicted are for as much as their psychological characterisation is concerned almost neutral. If they seem to have anything of an inner life at all, in that case it is mainly from their gestures that one perceives it. In fact Caravaggio draws from a relatively limited arsenal. A wide open mouth is a scream; the dirty look from the watershed eyes of the *The Taking of Christ* in Dublin; the in ecstasy folded hands of *Maria Magdalena* (fig. 17), the folded hands of one of the bystanders at *The Burial of Lucy* (fig. 14) in Syracuse, they are the most important elements of what in fact is a limited repertoire of formulas that are being used over and over again. But that repeating of familiar gestures, it is just that that determines the force of his art. It is a form of art that hits us because of its static pathos. We complete it with our own feelings: the often physical force of the work from his middle period, just before his escape in 1606, is easily to be interpreted as an expression of what seems to be happening not only on the canvas, but also inside the painter himself. The onlooker becomes what he sees. The painted body on the linen, becomes the

34

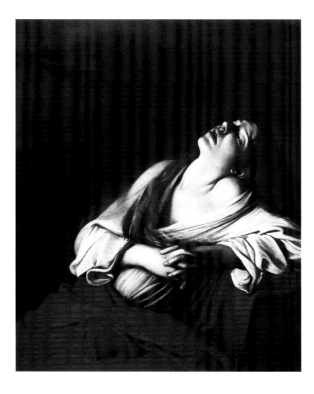

17 Caravaggio (attributed), *Maria Magdalen*, 1610, Rome, private collection

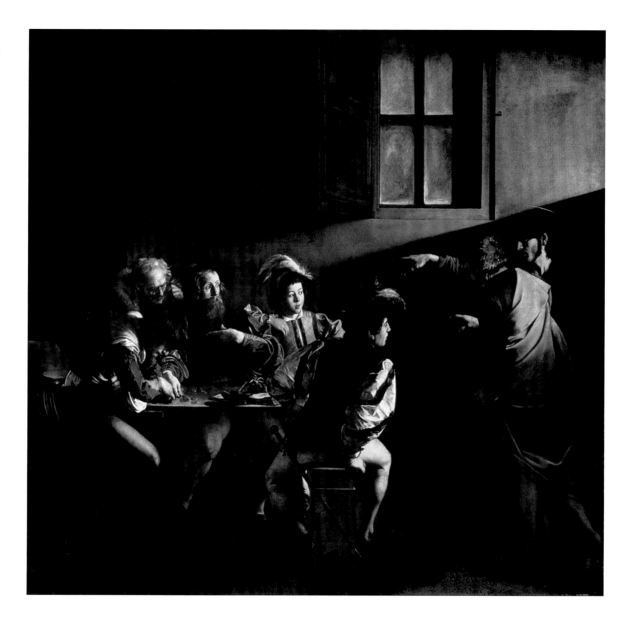

mirror of our emotions and gets used for our private goal. That way we forget that there were rules to the game that around 1600 channelled the emotional response. The pathos of work like the *Supper at Emmaus* (fig. 21) in London, but also the static nature of a painting like the one in Malta and also in the one with our John, create a *suspense* that serves to involve us in an action that takes place outside the painting in the empathy of the onlooker. Music will only be completed in the ear of the listener, thus wrote the afore mentioned Athanasius Kirchner. That goes the same for visual art.

It takes a little getting used to: Caravaggio is no psychologist. On the *Calling of Matthew* (fig. 18) in the Contarelli chapel the gospel writer is barely moved. That leads to a lot of speculation about the question what he actually feels. Not oppressed by the knowledge of the story and its interpretation in a long exegetical tradition, around 1955 one of the at the time most important experts on the work of Caravag-

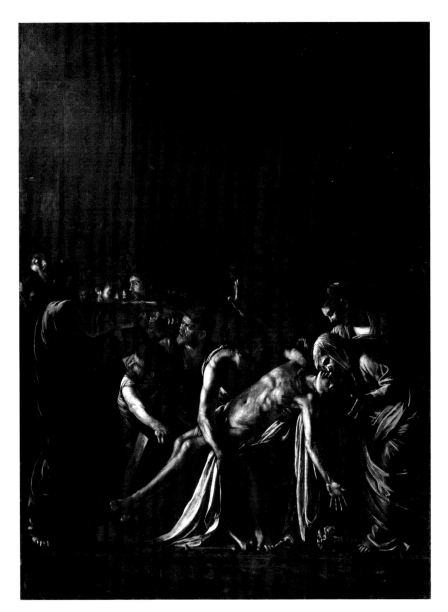

36

gio, Walter Friedlaender, makes it up himself. Matthews look expresses doubt, so he writes: the gospel writer is asking himself if it was him being called. He can't believe it. But that interpretation is squarely different from the way his reaction is described around 1600. The miracle of his Call was so great, that it leads to immediate result. He raises *at once* and follows Him. The quickness with which he answers the call, is in direct relation to the greatness of the miracle of grace that he receives.

JOHN LIKE A FINGER

Only now we become aware that all details, that on a first look seemed secondary, are laden with significance. Also the right hand of John is a sign. That hits us only when we realise that here it concerns a citation that Caravaggio has used before in the Contarelli chapel. There Christ indicates Matthew with an imperative hand. That indicating is a form of calling. The word becomes voice in the gesture. Also in

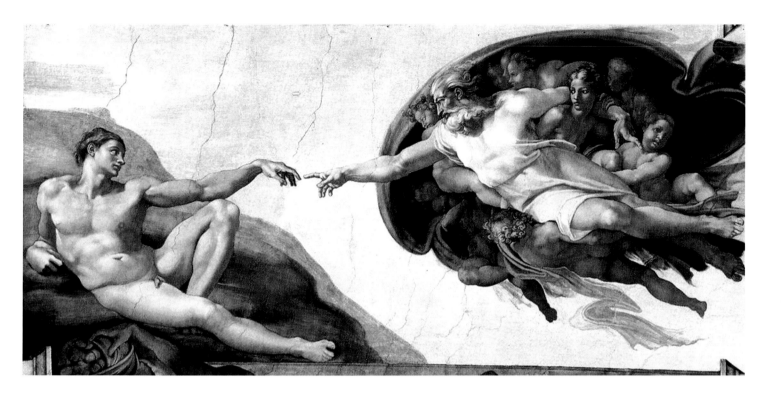

20 Michelangelo, *The Creation of Adam*, c. 1511, Vatican City, Sistine Chapel

The Raising of Lazarus in Messina Christ makes a similar gesture and here too he resuscitates that way the dead Lazarus back to life. Caravaggio thus makes use in an impressive way of a formula that still appeals to everyone's imagination and that derives directly from Michelangelo's ceiling of the Sistine chapel (fig. 20). There it is God that awakens Adam to life. He breathes life into him with the living word. But that also brings the hand of Adam himself to life. Michelangelo succeeds with one compelling formula in rendering visible a complicated theological concept. In fact on the Sistine ceiling it is all about the real birth of Adam, that is to say, the birth in the spirit. After the Fall of men Adam too has to remember this in order to make a chance to return to the paradise he lost by his own fault. That other Michelangelo, the one from Caravaggio, knows the meaning of this gesture. Matthew too is being called to life, in the spirit. And Lazarus raises from his sleep of death and spreads his arms wide (fig. 19). With this he imitates the Crucified Christ. The gesture shows that Lazarus knows that he is only alive because of Christ. The central theme of the Contarelli chapel and of the Cerasi chapel here returns. Each gesture gets sense and significance within a limited repertoire of subtle variations.

Caravaggio knows what he is doing. In his work he recreates the creation and brings, it even if it is just in appearance to life. The artist does what God has done: it is similar but not identical. Only the one that treats the creation and thus himself in a creative way outbids death. In the created the creator comes alive, but only when the make knows its Maker. In the 17th century God is still seen as the best artist, architect, musician and orator. That commonplace is part of a long tradition. Even the protestant poet, theologian and preacher Jodocus van Lodenstein (1620-1677) expresses this opinion forcefully in the seventh stanza of his poem titled *Gods' son in the flesh.* What should I really be saying, se he writes: *that the Creator becomes the cre-*

ation or that the creation becomes the Creator? The material becomes its own maker because it belongs to the Maker. Both is true, thus concludes Van Lodenstein.

This circular reasoning comes back everywhere, even as a musical form laden with content in the form of a figure called *circulation.* Josquin des Prés uses it and after him many composers of the 17th and 18th century. The English 17th century poet John Donne summarises it rather concise: *O Eternall, and most gracious God, who art a circle.*

It seems that Caravaggio too was familiar with this basic conception. And also our painting of John only functions well if we look at it keeping this idea in our mind (fig. 22).

The thing on the wall becomes John. That is the merit of the painter that made it. But we, when our turn comes, paint the painting. John is being created in our head. Helped by the painter we return to the saint himself. The naturalism contributes to the fact that what seems real, for an instant is perceived as real because we see it that way. It still is a means that helps with the meditation that goes as far as to become a form of contemplation that no longer has the need for the placebo that art is. The real art, thus informs the title of a book from the middle of the 17th century, is the art of prayer.

THE FINGER — OF GOD

In the literature about John is being put that in fact he is nothing else but a finger that indicates the coming of the Word. That pointing hand seems also to be the key to our John. What Panigarola does with words, Caravaggio does with paint. That awkward toy on the floor, that almost primitively self-made little cross (fig. p. 52), results to be prophetic. It is emphasised in our painting: a few small white strokes give the little cross of tangible and very material wood, substance: it becomes manoeuvrable, to us as well. It is enough to feel it to comprehend it. We know that it will become stronger and stronger in order that in the end it will bear Christ. Here too the painter does something that in the beginning goes unnoticed. Once you see it, you will not be able to forget it evermore. That little cross on the ground is not finished: or rather not finished yet. The two small pieces of wood are still lying on top of each other and are not connected. The cross is not finished; it is as if the ingredients are there: but that as a future means for crucifying it isn't ready yet. It is too small, it is not finished, in a certain way one could say that the cross too has to grow should it be able to carry the redeemer. Even in such an apparently secondary and rather unnoticeable detail, Caravaggio results to be capable of thinking of something that touches the essence of the theme by him depicted. One has to discover it, one has to see it, but once you've seen it you understand its meaning.

On that other picture of the painter that is hanging in the Galleria Borghese in Rome (fig. 8), John is not only older, but also the cross seems as if grown: it has become bigger and stronger, and much more in condition to serve as a means of redemption. Soon it is so big that it will be able to carry Christ. Here too we see that form of tautology: who bears the cross will once be crucified himself. The painting, apparently so simple, and of which the paint was barely dry so to say, when the painter took it with him on his last journey back to Rome, refers to the entire œuvre of the painter. Those that do not see through the details and live them, are blind.

The painter plays a game with his public. He evokes, summons, anticipates, suggests what will come, but what is really happening he doesn't show. That is enacted only in the head and the hart of the beholder. But because Caravaggio is holding back much more than he shows, he offers us the chance of imagining the story around the work ourselves. A minimum of action results in a maximum of movement. But what moves is translated in a form of inner emotion. Without us the painting has no right of existence. Caravaggio's art is a form of art for public, but then just for the wise. For the generation of painters that comes right after Caravaggio this is not enough. His work is considered to be almost boring. It is only good in the reproduction of the matter, he is not capable of doing much more then that. In his naturalism he is one-sided, and worse, even limited. There is no room for the spirit. The painter doesn't tell. The believer is not being involved in the story. In that art that doesn't play a role. The stream of events does not carry him along. In the art after Caravaggio, according to Bellori, human emotions are being shown and those help us to feel our own emotions according to the example. Because of them we too feel who we are: those we see there on the painting, are witnesses, and the fact that they

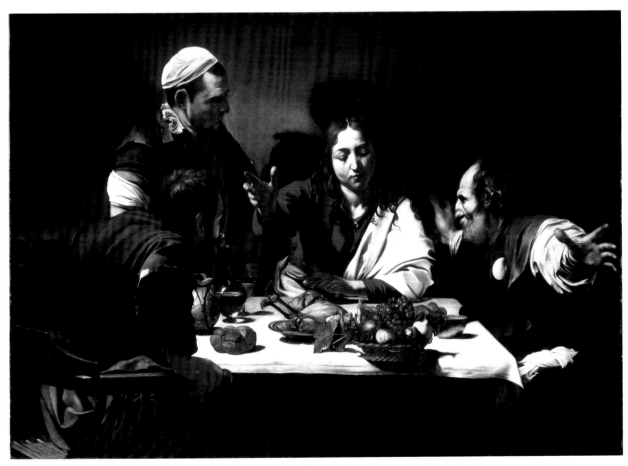

21 Caravaggio, *Supper at Emmaus*, 1601, London, The National Gallery

are we notice because they, just like ourselves, have an emotional reaction. They become an ingredient of the representation itself and show their involvement in what happens. That makes that art theatrical and that pathos may irritate: in the baroque theatre, in the baroque art of painting of after Caravaggio everything one self feels too, is visible. The user plays a part in the piece and his own emotions are those of the *cast*. He plays a part in the piece but that way also hands over the direction. In fact he looses himself and that's what he is supposed to: for the painting of Caravaggio he has to do far too much. That leads to a form of individualism which is not without danger. The art after Caravaggio is aiming for total control: with Caravaggio that lacks. We are not being dragged along in an ecstasy, but we have to do it all by ourselves and think, with all inherent dangers.

WHAT WENT ON IN THE HEAD OF THE PAINTER?

40 In the Contarelli chapel the art returns to the street. Even so every painted detail is at the same time also a sign. What we see is a potential spiritual theatre that is being started with the help of grace. The work of Caravaggio helps the believer too little on his road of getting along. It is also, according Bellori, too vulgar. Each form of higher beauty is lacking. Because it doesn't surpass reality, each form of grace is missing and grace is the manifestation of mercy. The work of Caravaggio, so writes cardinal Ottaviano Paravicino in 1603, keeps the middle between devotional and profane.

Here too it seems that Caravaggio's art in the 17th century was strongly tied to the moment the painter made it. In fact as a devotional means it is around 1620, at least in Rome, outdated. The trick doesn't work anymore. The street in front of the church and the space within are played off against each other. Who enters the church, has to feel the spirit and that is light. In the Contarelli chapel inside you are still outside. And yet that is just the force of his naturalism. There is no misunderstanding about the fact that one has always and everywhere to do things by oneself. But not even twenty years later, one stands in the baroque space of the 17th century already almost with one leg in heaven. There belief comes off triumphant and there is no misunderstanding about sharing that triumph of the church. The art after Caravaggio becomes a form of revelation and brings with all the tricks at disposition the believer in ecstasy. In the work of Caravaggio there is no room for that kind of ecstasy. Everything happens outside the frame. The work is a means at service of the faithful contemplation, of the meditation. It just helps the believer in getting on his way. The sort off boring glimmer of light at the right on the painting with *The Conversion of Paul* (fig. 3) in the Cerasi chapel is to meagre for a promise. And also on our painting, it is there, but it isn't much yet.

When Francis was asked why he had not retired into a monastery, he is supposed to have said that the whole world was a monastery. A monk one was also in the world. Within that tradition Caravaggio's naturalism fits too.

Maurizio Marini, who has reconstructed the origin of this painting comes to the conclusion that it must also have touched the painter. It is, he wrote, also an open confession of guilt, repentance and at the same time of hope. For the painter too the light of the hope of redemption that the saint predicts glimmers. With that, it becomes at the same time a form of prayer. What the painter asks of John, he also asks the pope and his nephew: he too wants to be able to hope for grace. The murderer thus confesses his guilt and he knows: without repentance there is no chance for forgiveness. The light that falls on John, almost falls on him. Christ still stands, so writes Marini, *fuori campo (off side)*. The prayer is still caught in the throat of Caravaggio. By painting John he cries for him and begs for help. Thus it becomes a cry for redemption and a sign of hope.

It sounds rather pathetic, but maybe Marini is right. What has happened on Malta, and also after, must have left its traces. The signature on *The Beheading of John the Baptist* (fig. 7) is all but an ordinary sick joke. What he paints regards him now *personally*. The painting of *David and Goliath* (fig. 11) in the Galleria Borghese is just as much a statement. The painter himself is Goliath, a villain who's head has been righteously chopped off by a David wrapped only in the nakedness of his belief. For that reason Goliath still came to the faith, when it was almost too late. His death forms the right punishment for his sins.

On the dramatically big altarpieces in Sicily everything that hints doubt seems to have been eliminated. The painting with the young lying John is almost bare. The boy seems real. And still we know he is a *fake*. The only real John lives in our head. With the help of the painting we also see him in the hart. Only when we realise who that boy there is, an inner process starts up that makes us *week* and almost ill for love. Love for Him: 'I am ill for love' it says in the Song of Songs, the book from the Bible that is considered to form the basis for mystical experience. Because I languish for love, it was called in chapter 2, verse 5: *Quia amore langueo*, thus the text of the Vulgate. It here concerns sin, repentance, faith, hope and the motor of this all, love. John knows what we now know. And what John knows, the painter also knows. When he painted him, he must have seen him. Has he seen him for real laid down in front of him? Did he recognise him in a model that he had in front of him? Do we really know what he knew? Didn't it all only begin where the painting stopped? Work and person are never to be parted again, especially in Caravaggio.

pp. 42-43
22 Caravaggio, *John the Baptist reclining*, 1610, Munich, private collection

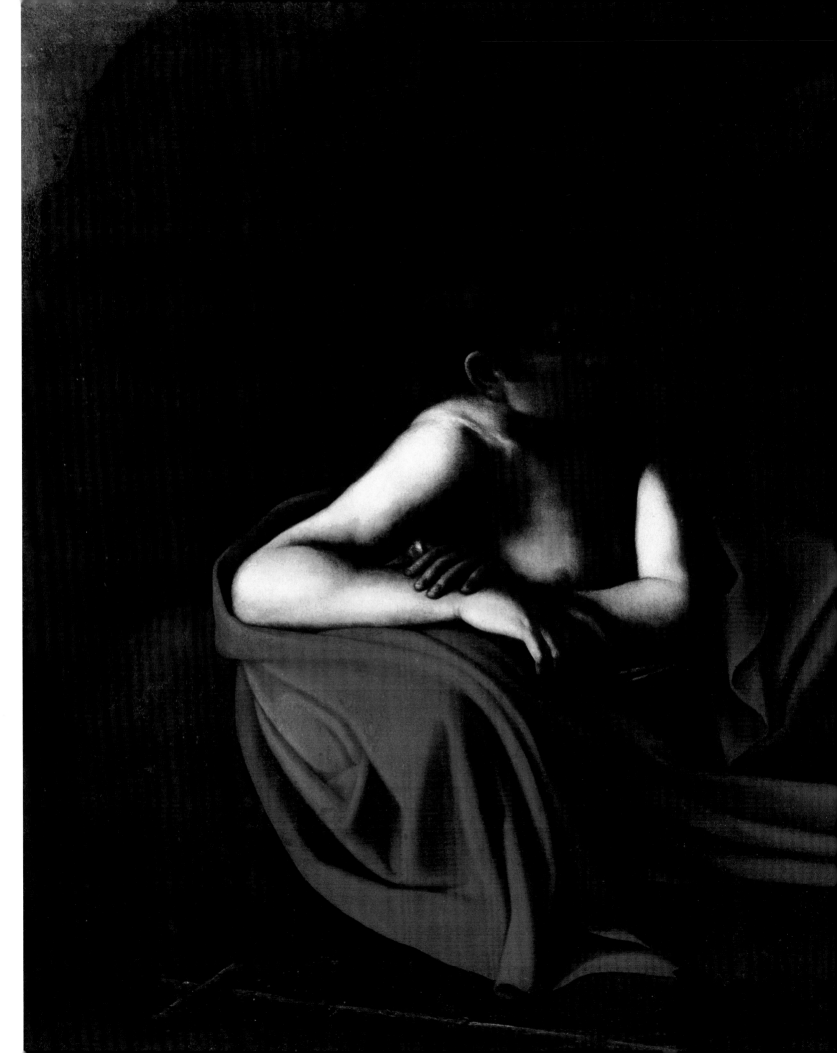

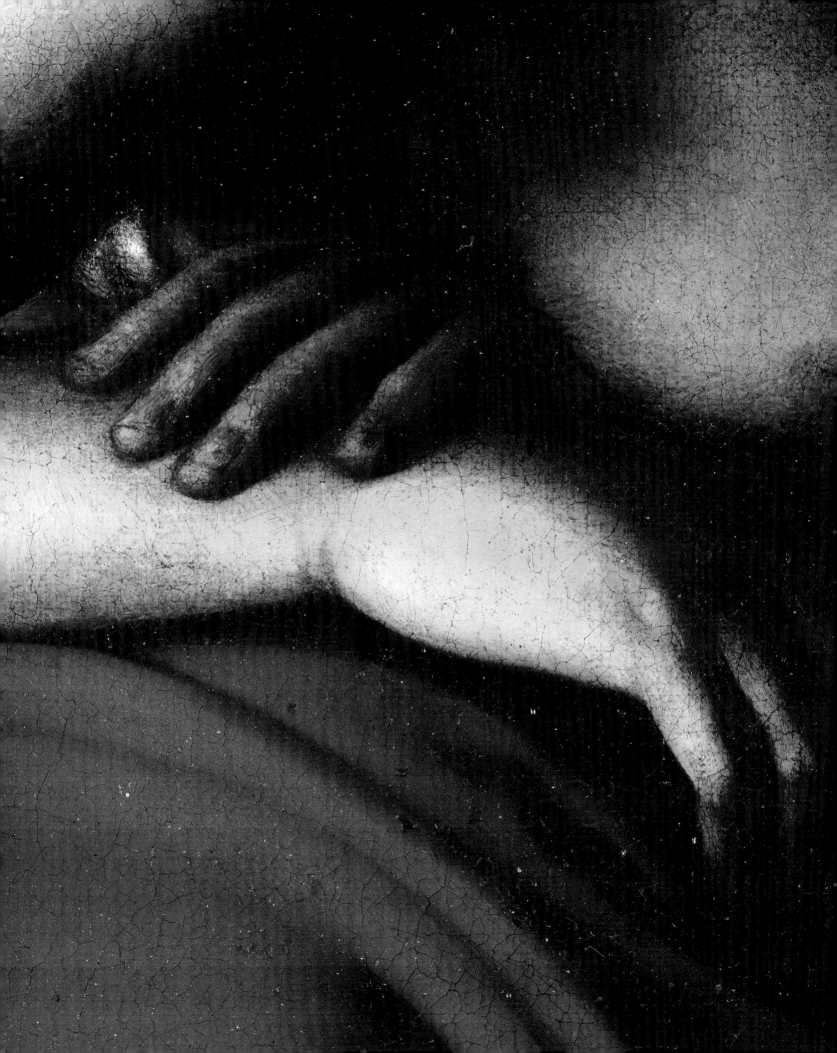

A Neapolitan trace and some notes to the *John the Baptist reclining* by Caravaggio

Vincenzo Pacelli

The stay of Caravaggio in Naples in periods of different duration and alternated by intervals in Malta and Sicily is being measured by work almost all attested by documents.[1] The activity of this last period[2] is like has been recognised by everyone the richest in experience and knowledge: it marks the artistic Neapolitan scene till half of the 17th century, when Prete and Giordano transform their naturalistic credo, during the fifties, in a language already completely baroque.

Paintings like *The Seven Works of Mercy* (fig. 5) for the Pio Monte, the *Scourging* for the Chairman De Franchis, *The Madonna of the Rosary* (fig. 23) for a commissioner yet to be defined, *The Crucifixion of Andrew* for the viceroy Count of Benavente, work done in the first period after his arrival in town, have become, together with all following canvasses, amongst which also the three lost paintings of the Fenaroli chapel of the Sant'Anna dei Lombardi-church, and then *The Martyrdom of Ursula* (fig. 12) painted in May of 1610, the pictorial texts on which the Neapolitan masters like Battistello Caracciolo, Carlo Sellito, Filippo Vitale, the Master of the Annunciation to the shepherds and others still, could learn the naturalistic lesson that Caravaggio was able to teach with great knowledge.

This last painting in particular, *The Martyrdom of Ursula*, attributed to Merisi only in 1980 thanks to inconvertible documents, has to be remembered because of its stylistic bond to the little John (fig. 22).

In the last months of his life, Caravaggio, from November 1609 on, returned to Naples from Sicily, he made, like documents demonstrate, other paintings that hang side by side with the more celebrated *Ursula*, now in Naples in the gallery of Palazzo Zevallos Stigliano head office of the Intesa Bank. Amongst these, the *John the Baptist seated* (fig. 8) now at the Borghese, the *David and Goliath* (fig. 11), on which there is the most tragic self portrait of all those he painted, in the same gallery, and from the documents found back in the Secret Archives of the Vatican the memory of the three paintings, being the two *John*'s and a *Magdalena*, according to what the Apostolic Delegate of the Kingdom of Naples Deodato Gentile refers. These paintings were meant for Scipione Borghese, the powerful secretary of the Vatican State, nephew of Paul v Borghese, that, after many a 'coup de théâtre', came into the possession of just one of the two *John*'s, that ever since 1611, is still being kept in the Galleria Borghese. Also from the other two paintings, the other *John* and the *Magdalena*, the story of their past up and until today's events has been reconstructed.

45

1 For *The Scourging* De Franchis, cfr. V. Pacelli, 'New documents concerning Caravaggio in Naples', in *The Burlington Magazine*, c x i x, n. 897, 1977, pp. 819-829; for *The Seven Works of Mercy*, cfr. Id., *Caravaggio. Le Sette Opere di Misericordia*, Salerno 1984; for *The Martyrdom of Ursula*, cfr. F. Bologna, V. Pacelli, 'Caravaggio 1610: la 'Sant'Orsola confitta dal tiranno' per Marcantonio Doria', in *Prospettiva*, x x x i i i, 1980, 23, pp. 30-45.
2 Cfr. V. Pacelli, *L'ultimo Caravaggio dalla Maddalena a mezza figura ai due San Giovanni (1606-1610)*, Todi 1994.

46

The three paintings, at the moment of the imprisonment of Caravaggio in the dungeon of Palo,[3] like it reads in the letter of July 29th 1610, are being brought back to Naples to the house of Costanza Colonna, marquise of Caravaggio, that had given hospitality to the painter. The *Magdalena* must surely be identified with the *Half-length Magdalena*, mentioned by Bellori, painted in 1606 on the estates in Latium of the Colonna's, when the painter had left Rome because of the death of Tomassoni in duel. This work, his most copied by Neapolitan artists like Battistello Caracciolo, Filippo Vitale e Andrea Vaccaro, who became the poet of this type of iconographic theme, and by Flemish artists like Finson and Wibrant de Geest, must have been very dear to Merisi, if it is true that he takes her with him to Naples to give her to cardinal Borghese, so that he would help him with his uncle pope in order to be granted grace and return to the city.

Like correctly has been assumed, even this work, from the three that were on the

3 About the last, tragical events of the exsistence of Merisi, cfr. V. Pacelli, 'La morte di Caravaggio e alcuni dipinti da documenti inediti', in *Studi di Storia dell'Arte*, 2, 1991; cfr. anche Id., *L'ultimo Caravaggio 1606-1610. Il giallo della morte: omicidio di Stato?*, Todi, 2001, pp. 210-234.

ship, finds its destination; it comes into possession of the marquise Colonna and, because of matrimonial events, in that of a member of the Carafa Colonna and later ended up in Naples in possession of the rector of the Cathedral and finally in a private collection in Rome, where it is still to be found, sold in the sixties by the lawyer Klein, name with whom it is still identified even today.

And then finally, here we are at the painting that is now of our concern, the John the Baptist, this too was to be found in the group of three paintings with destination Borghese. In the events of the three paintings, like is to be found in the letters of the Secret Archives of the Vatican, besides the marquise Colonna and cardinal Borghese, through apostolic Nuncio, the count of Lemos manages, with all the authority deriving from his role, viceroy of Naples, he who arrives in town in July 1610, too late to be able to commission Caravaggio anything, Caravaggio from whom his predecessor had succeeded to obtain the *Crucifixion of Andrew* which today hangs in Cleveland, to play a part.

Well then, like demonstrated by the events, the viceroy succeeded in laying his hands on one of the two *John*'s, the one that concerns us now, and from the other, that almost at the same time ended up in the possession of cardinal Borghese, he had a copy made.[4]

According to the reconstruction of Marini, who was the first to publish *John the Baptist reclining* in 1978 and attribute it to Caravaggio[5], the painting had followed the count of Lemos to his native country and then to Latin America, to Peru, where his nephew was viceroy. Subsequently, because of hereditary matters, the painting must have followed Pedro Antonio Fernando di Castro, 10th count of Lemos, grandson of the more famous viceroy (1667-72). The painting, like is known by now, is coming from a collection of a noble lady of Argentine nationality that moved to Germany. The attribution of the painting to Caravaggio is sustained by various experts: amongst others, needs to be remembered the favourable opinion of who, like Federico Zeri[6], Treffers[7], Robb and Spike and other experts of world fame like Claudio Strinati, master Pico Cellini (already known for his important restoration work and attributions of paintings to the master from Lombardy like the *Ecce Homo*, the *Judith and Holofernes* (fig. 24) and the *Denial of Peter*), Stephen Pepper, Leonard J. Slatkes, and Michael Staughton, that all agreed, in private letters, with the attribution of the painting to Caravaggio.

These are the historical events of the painting, that state its caravaggian autography by its stylistic matching approach both with the *John the Baptist seated* of the Galleria Borghese, its twin, as with the *David and Goliath* of the same collection, but most of all because of its stylistic-compositional analogy with *The Martyrdom of Ursula*. In these paintings, united with the John the Baptist the pictorial ductus is characterised by a poverty of material, an 'impasto' reduced to the minimum, that in an able way takes advantage of the way the light poses as well as the preparation just like in the paintings of the terminal phases of Caravaggio. Thus the light and the shadow play a fundamental role in the determination of the physicality of the material, in addition to the bearing of the sentimental aspects of the subject, perceived through the reaction of a muscle, an imperceptible movement of the body.

The spiritual concentration of the Forerunner of Christ, is perceptible in the tension of the fixed look that peers into the distance, almost foretelling already the important role he is called to play, of the one that announces and prepares the coming

4 M. Marini, *Io Michelangelo da Caravaggio*, Roma 1974, pp. 59, 284 cat. 93; Id., *Caravaggio. Michelangelo Merisi da Caravaggio 'pictor praestantissimus'*, Roma 1987, pp. 556-557; V. Pacelli, *L'ultimo Caravaggio dalla Maddalena a mezza figura ai due San Giovanni (1606-1610)*, cit., pp. 130-158.

5 M. Marini, *Michael Angelus Caravaggio Romanus. Rassegna degli studi e proposte*, Roma 1978 [1979]; Id., in *Io Michelangelo da Caravaggio*, cit. ed. 2001, cat. n. 111, pp. 574-575.

6 F. Zeri, 'La vocazione di San Matteo', in *Cento dipinti*, n. 2, Milano 1998, pp. 28-45.

7 B. Treffers, *Caravaggio nel sangue del Battista*, Roma 2000, pp. 73-82.

of the Messiah. All that originates just from the light, like always protagonist of the paintings of Merisi. Coming from above and from left, hits the shoulder, the arm, the forearm, the right hand and part of the breast. Glides to the left forearm, polishes the thighs, generating the scanning of the layers between light and dark, linked by that big red cloth, that here with a light and brilliant tone of colour, soaks a soft and light material thus recreating folds, soft and natural as well, like the *San Giovanni* (fig. 15) of Kansas City or the one of the *John* (fig.25) of the Corsini, but also the tone of colour of *The Adoration of the Shepherds* (fig. 26) of Messina, the painting with which John defines a strong analogy in the pose of the Virgin, she too resting on an element of sustain. That position, as well as the red cloth on the one as well as the other painting, take their movements right from the *Magdalena* Klein, obviously varying and dosing the position according to the different drama they recite. However, one should keep in mind that these are paintings that have been created within a period of few years, and that in spite of the experimentation of new ideas, some, like the one with the red cloth, or of certain poses, remain constant in the pictorial universe of Caravaggio, and that just because of their iteration they exert great fascination with the most sincere followers of Caravaggio.

48

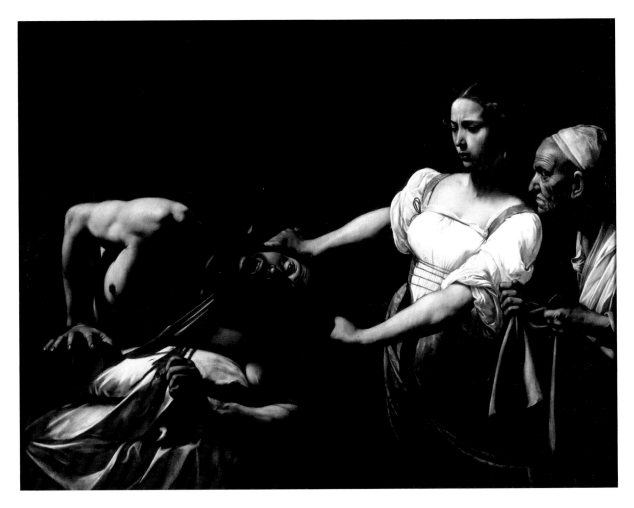

24 Caravaggio, *Judith and Holofernes*, c. 1598, Rome, Galleria d'Arte Antica di Palazzo Barberini

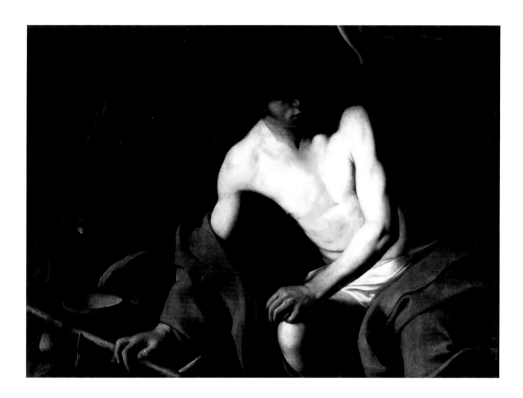

49

So, even the light is a part of these constant items of Caravaggio and, directed on the figure of the Baptist, programmatically set on the left half of the canvas, like a classic sculpture, ends its course right there on the red cloth, like on the one of *The Adoration of the Shepherds* of Messina made just a few months before.

In front, near the edge of the canvas, a simple cross, almost certainly made of canes, just like the others that complete the many paintings of John the Baptist done by Merisi. The painting is constructed on a scalene triangle, of which the short side departs exactly from the right elbow and, passing by the head, ends on the left leg, while the basis begins at the angle with the red mantle, to conclude itself on the elbow of the right arm.

Like in the other paintings of the same theme, Caravaggio has observed a juvenile pattern, and here too, a reference to the element of a still life, although brought on most certainly in an original way, at the back of the young man and at the bottom of the wall, is not lacking.

For as much as the proper stylistic aspect is concerned, the painting will be more easily comprehended after the last restoration that will above all evidence the 'Neapolitanity' of the painting done in contiguity, like mentioned before, with the *Ursula*, the *David and Goliath* and the other *John the Baptist seated* of the Borghese.

This painting has not been, compared to the *Magdalena* and other paintings of Caravaggio, taken for an example as often by the Neapolitan painters, and is totally absent in the Roman production, with the exception of the *John the Baptist* of Paolo Finoglio that reproduces the position of the legs almost to the extent of a superimposition, with the few variations of the face turned to the onlooker and the cane held in the left hand perpendicularly to his body. This is totally plausible for the impossibility for the painters usually admitted to his workshop in order to see his work, because of the very short period the painting must have been there. Amongst the

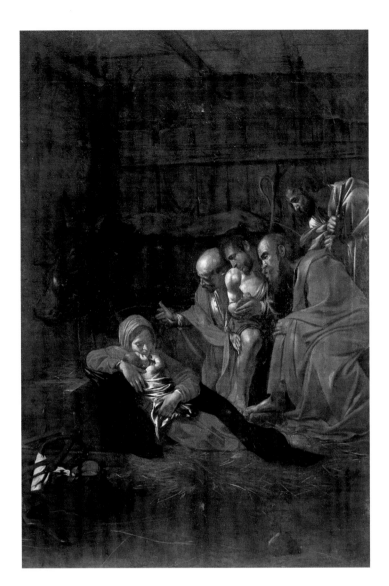

50

few that saw it, and were interested in copying the iconographic novelty, reached us, like said before, only the iconographical testimony of Finoglio,[8] important anyway to enforce the thesis of the attribution and done entirely by Caravaggio and in Naples of the painting.

With respect to the iconography, the figure of the Baptist has been variously interpreted: the gospel writers present him as an apocalyptical figure, Giuseppe Flavio as a moralist, byzantine art like an ascetic, the humanistic-renaissance speculation as a prophet. Only in naturalistic circles he found an expression that corresponded more to his role as forerunner and preacher. For the dramatic force tied to the event and because of the force of the naturalistic expression in the circles of Caravaggio, his decollation was diffused.

John the Baptist is amongst the most exciting personalities of the gospel. Forerunner of Christ, he forms the connection between the Old and the New Testament. On basis of the chronology of the gospel of Lucas, John appears in the 15th year of the Reign of the Emperor Tiberius (29 A.C.) in the desert of Judea as a preacher of penitence and to announce the coming of Christ. Of priestly origin, son of Zacharias

8 V. Pacelli, *L'ultimo Caravaggio dalla Maddalena a mezza figura ai due San Giovanni (1606-1610)*, *cit.*, ed. 2001, p. 151, fig. 66 a p. 152.

and Elisabeth, according to what Lucas says, he lived in the desert until the day on which he had to reveal himself to Israel. A series of converging indications render probable an influence of the Essenes of Qumran on the education and the prophetic preaching of John. Lucas says that the Baptist lived in the deserts, Christian sources specify that he is talking about the desert of Judea, south east of Jerusalem, along the Jordan river and the Dead Sea, practically in that region where the Essenes were. The text that characterises the office and mission of John is Is. 40:3: *A voice shouts out in the desert: make way for the Lord, smoothen his paths*: in the same way this characterises the Essenes.

Anyway, John lead an ascetic life, he preached and baptised those that came to him repenting their sins in the waters of the river Jordan. Covered by a skin, like has been said, he fed himself with wild honey and grasshoppers. Like the baptism of John recalls for many aspects the ones that the Essenes practise, also his food is similar to that of which the food of the community consisted of. But all this does not proof that John was an Essene.

His arrest by Antipa, son of Herod the Great, did not occur out of fear for an insurrection as a result of his preaching, but because of the reproaches addressed to the tetrarch, because of the irregularity of his marriage. These facts are narrated in the gospels according to Marcus, Matthew and Lucas and confirmed by Giuseppe Flavio.

In the representations of the various Johns and little Johns of Caravaggio, always the Baptist, never the Gospel writer, it does not seem, from a first analysis, that the painter wanted to enter in the complexity of the figures of the Forerunner of Christ. Except for the iconographic theme of the Decollation of the Baptist, whether during or after this has already been done, all other paintings figuring John – approximately twenty paintings – the gospel preacher is almost always shown as a young man, or little more then an adolescent, and what's more entirely in the nude, and covered almost always by a red cloth that covers his loins, in a pensive attitude often sitting on a rock or a trunk, in the solitude of a desert, sometimes accompanied by a grown lamb.

So we are talking about an iconography that in itself forms an original choice. Maybe from the ideological aspect he actually wanted to underline that moment of the life of John while he was meditating, waiting for the Word. It can't be underestimated either, at least for as much as composition is concerned, that Merisi in portraying the Baptist meditating, has had the possibility to realise one of the most beautiful young nudes of his production: think of the fact, apart from the one of the Corsini, the one with the grim look of Kansas City, that aside from those that compare it to the bust of the *Apollo* of Belvedere, he doesn't appear like a prophet, in the promised countenance of a prophet, but rather in the classical vigour of the *Ludovisi Mars* of Palazzo Altemps or an athlete that cleanses himself with a strigil, an *Apoxyomenos* borne of the chisel of Lysippus or other classical or Hellenistic sculptors.

About the last two paintings depicting John the Baptists

Maurizio Marini

Amidst the many reports of allegedly unrecognized paintings by Caravaggio that from 1973 until now landed upon my desk, only one has adhered to the unflinching requirements of authenticity and philological adherence; the supremely relevant *John the Baptist reclining* (fig. 22), thus addressed to distinguish it's iconography from the theme of a young Baptist, often perused by Caravaggio.[1]

The report itself originated from Munich, coming from a local trader, charged with the task of confirming the attributed paternity. The included photographic evidence (of good quality) displayed an oxidized and dirty surface, with some damage to the paint and the canvas. Even so, what did show in the black and white picture, was enough to motivate me into a pre-emptive research, focused on the lost pieces of the last days of the great artist. The images I was required to examine hinted strongly to that final period of the artist's live in it's technical and conceptual character; a first impression that was later confirmed upon direct observation of the *John the Baptist reclining*. On that occasion, taking into account the state of deterioration, I reported the extreme necessity to control the damage and proceed with restoration as quickly as possible, to preserve it's quality, with special focus on relining the canvas (measuring 106 x 179.5 cm).

This initial salvage operation was paramount to preserve the possibility to verify (or debunk) the authenticity of the attribution to Caravaggio; approximately located, time-wise, to the year 1610; indeed the final days of Caravaggio, who dies in Porto Ercole (in the Spanish State of Presidi on the Argentario) on the 8th of July

I thank dr. Federica Gasparrini, Jovan Mizzi and Antonio Vannugli for their precious collaboration.

1 John the Baptist (apart from being eponymous of his brother the priest) is a figure of importance in Catholic devotion. Forerunner of Christ he is raised to be patron of many Italian cities. I remind in particular Florence and Genoa, as well as the cathedral in Rome, dedicated to the namesakes John the Gospel writer and, exactly, the Baptist. Like already said, the theme is frequent in Caravaggio. The oldest, known today, should be the one from 1602, conserved in the Sagrestia named Cathedral of Toledo. Of analogue chronology is the *John the Baptist* formerly Mattei-Del Monte of the Pinacoteca Capitolina (dedicated to Giovanni Battista Mattei); also from 1602 is the version that now is in Kansas City, W. Rockhill Nelson Gallery of Art which belonged to the banker from Liguria Ottavio Costa. To a later phase of his Roman period, in 1606, should belong the *John the Baptist* of

the Corsini Palace in Rome, In an infant version he appears in the *Holy Family*, maybe commissioned by the Duke of Modena between 1605 and 1606, but painted in Naples in 1607. However the most important testimonial of the young years of Caravaggio concerns the *Decollation of the Baptist* for the Oratory of the Knights of Malta, or rather the Order of St John in 1608, in La Valetta. On the contrary in infantile forms he appears in the act of quenching his thirst at a fountain on a canvas of the Bonello Collection in Malta, of 1608. The decollate head in the basin of Salome in the similar compositions, of 1607, London, National Gallery

of 1609, Madrid, Palacio Reàl. The last paintings are thus *John the Baptist seated*, of 1610, today in Rome, Borghese Gallery, and exactly, the on with the *Baptist reclining*, of analogue chronology, as well the same model cfr. M. Marini, *Caravaggio, 'pictor praestantissimus'*, Roma, ed. 2005, nr 56 (pp. 240-241); nr 58 (pp. 244-245); nr 62 n. 72 (pp. 272-273); nr 79 (pp. 286-287); nr 90 (pp. 308-309); nr 94 (pp. 316-317); nr 82 (pp. 292-293); nr 99 (pp. 326-327); nr 109 (pp. 346-347); nr 111 (pp. 350-351).

2 The painter dies in the hospital of the Company of the Holy Cross, next to the Dome of St. Erasmus.

that same year.[2] At the finding of the *The Martyrdom of Ursula* (fig. 12) (which hangs in the Zevallos Gallery in Naples) it had been established how Caravaggio was supremely active in his final days in Naples, cramming together important public and private commissions.[3] This level of intensity was aimed to secure passage towards Palo, with the intent of then reaching Rome with some leisure, carrying with him the *John the Baptist seated* (fig. 8), required off him by Cardinal Scipione Borghese,[4] whom, in his function of Plenipotentiary in all matters of Papal Justice, held the final say on the painter's ban from Rome, following the murder he perpetrated in 1606.[5]

The correspondence of Lanfranco Massa, representative in Naples to Marco Antonio Doria, Duke of Genoa, is unmistakable where it lists the demands of his master to Caravaggio, at the time still alive, and to Battistello Caracciolo. Adding to the already mentioned *The Martyrdom of Ursula*, he means to ask Caravaggio, whom he refers to as 'his friend', for a second painting.[6]

Pictorial and carved citations in Caracciolo's work,[7] as well as the unyielding devotion the Doria held for the Baptist (patron saint of Genoa, who's relics were guarded by the Doria family) are a strong indication that the subject of the next painting had to be the Baptist himself; a theme often explored by the artist. Cardinal Scipione Borghese himself carried a strong interest towards the Baptist, which ads further weight to identifying this as the most likely subject of the painting.

Caravaggio's role in this commission was further confirmed by correspondence between Deodato Gentili, papal nuncio (ambassador) in Naples, and cardinal Scipi-

54

3 The exchange of letters between Lanfranco Massa, attorney in Naples of the Duke of Genoa, Marco Antonio Doria, (a letter sent May 11th, 1610 and arrived in Genoa the following 26th) reminds the commission to Caravaggio for *The Martyrdom of St. Ursula*, and the intention to ask for another painting (see for the rest in the text). And in the same chronological context had been proposed to Caravaggio 'Pictor insigne' to realise the big *Circumcision of Christ*, for the Santa Maria della Sanità (recent radiographic research, 2005, has revealed a big sketch under the now visible layer of paint, that has been completed by Giovanni Vincenzo Forlì after 1612. Caravaggio had been ordered a big painting (*The Multiplication of the bread*?) intended for the decoration of the refectory of the Teatini ai Santi Apostoli, also in Naples. The text reminds of an advance payment of thirty scudi to the painter 'che havea promessa: ma perché fu ammazzato, si perde la pittura con i denari' ('that made a promise, but got killed and so the painting, as well as the money, is lost'). All this to confirm the bulk of work Caravaggio was doing in his second period in Naples, which makes it probable that once he had solved his problems with the Roman justice he would have had to go back to Naples in order to do what with the receiving of a substantial amount of money he had accepted to make (cfr. Marini, *cit.*, 2005, nr. 110, A, pages. 570-571; nr. 107,

pages. 566-567; p. 127, note 557 (with previous bibliography); pp. 103; 105; 128 (note 572).
4 Cfr. Marini, *cit.,* 2005, nr. 109, pp. 569-570.
5 Cfr. *Ibidem,* 2005, pp. 66-67.
6 Cfr. *Ibidem,* 2005, nr. 110, p. 570, A.
7 Cfr. M. Marini, *Dalla casa al museo – Antologia di dipinti dei secco XVI-XVIII, dalla Raccolta Signorini-Corsi al Museo Civico dell' Aquila,* Teramo, 1992, nr. 7, pages. 28-34 (in part. p. 31, fig. 7-C).
8 Cfr. V. Pacelli, *L'ultimo Caravaggio dalla 'Maddalena a mezza figura' ai due 'San Giovanni',* Todi (Perugia), 1994, pp. 121, 126-130. See also Marini, *cit.,* 2005, pp. 102-105.
9 The State of the Presidi (State of the Garrisons) in Tuscany, that was situated between the area of Grosseto and the promontory of the Argentario (with fortified centres like Orbetello, Talamone, Porto Santo Stefano and Porto Ercole), fell with the competence of the defence forces of the Spanish Crown in the Tyrrhenian Sea, and therefore in strict connection to the territory of the Viceroy of Naples. Of particular interest is the presence of a population mainly consisting of Spanish military, fishermen and other craftsmen, just to confirm the imprint of their politics to guarantee maximum security, all rigorously immigrated from the Spanish territories and relative islands (of which the surnames of the population are still testimonial today). The maritime service with felucca's,

between Naples (from where they probably started out on Monday), with a stop in Procida, (maybe to bring drinking water and embark some passengers) just to restart for Porto Ercole, where arrival was foreseen after four, five days of untroubled and uninterrupted navigation along the coast, between Terracina and Civitavecchia. The docking at the terminal was supposed to take place in the hours immediately before sunset. The stop and the 'rearmament' had to be between the dawn of the day after arrival and the Monday before leaving again for Naples. In this particular case, if the Monday of the start-out from Naples was the 12th of July, the landing for the painter at Palo must have taken place three days after. The misunderstanding, with arrest, must have been a quick event. The liberation of the painter, with the payment of a bail, could have been with the guarantee of a member of the feudatory family Orsini. These could have arranged for a boat for Caravaggio in order to sail out to the terminal of the felucca on which his painting-safe-conduct for Cardinal Borghese had remained. The trip of 40 miles (provided there were no atmospheric disturbances, but it was July) could have been covered in more or less 10 hours sailing, which means that Caravaggio must have reached the completely fortified harbour of Porto Ercole and the felucca was still there. Caravaggio must have communicated his name and address

one Borghese himself. The correspondence took place immediately after the death of the painter.[8] Borghese worries about his *John the Baptist seated* when Caravaggio is placed under arrest by the papal gendarmes, as soon as he sets foot in the harbor of Palo. According to the legal procedure in use in customs, the painter was a fugitive murderer, condemned in absentia. Putting ashore in proximity of the castle of Palo (a stronghold belonging to the Orsini family, related to the Caravaggio marquis) must have been an explicit request by the painter, and was a deviation from the route planned by the felucca he had boarded. The boat's intended route had been to travel from Naples to the Presidi States in Tuscany.[9] The tide and the need to make up for the delay caused the boat to resume it's route towards Porto Ercole forthwith, taking along the personal belongings of Caravaggio, including, most importantly, the cardinal's John the Baptist. The fate of the artist, and his papal pardon depend on this painting. After some debate with the commanding officer, Caravaggio negotiates towards posting bail, vowing to return to Palo once he's regained possession of his painting.[10] With a provisional permit in hand, the painter boards the first available transport towards Porto Ercole, final destination of his original vessel. (sea travel was still his fastest and safest option).[11]

The timeline suggests that he arrives in Porto Ercole on the 16th of July, a Friday, probably already in poor health. He died on the next Sunday, in the hospital of the Compagnia della Santa Croce.[12]

Ironically, the felucca with all his possessions aboard is anchored in the nearby roadstead, waiting to leave for Naples on the morning after his death. Yet another

and his membership of the Order of Malta (oblivious of his expulsion), as well as the urgency of the recovery of his luggage from the Neapolitan felucca, above all of the painting with John the Baptist, purpose of his eventful arrival. However, the body (exhausted by the fever that was probably caused by assuming infected water or food during the voyage from Naples), was debilitated in an irreversible way. According to local orders the foreigner that had arrived ill had to be kept in isolation and to be entrusted to the cures of the Company of the Holy Cross (an explicit military denomination). These were obliged, by charter, to take him in their care and, in case of death, to draw up an inventory of his belongings, as well as communicate this to his relatives and where he came from: the inventory had been sent to the Prior of Capua of the Order of Malta for scrutiny. The latter declined the interest of the Hospitallers, because the painter was no longer part of this order, but had transferred it to the Spanish authorities in Naples, in particular to the Viceroy, the Count of Lemos. The last, because of the subjection of the painter to the Spanish crown, had claimed the rights to his belongings, amongst which *John the Baptist*. The doctors of the Holy Cross had not been able to do anything but to state the rapid decay of that body that was no longer capable of reaction, till the end, on July 18th (Sunday). Hence the realisation of

what was foreseen and the burial (considered temporary) in the small graveyard *extra muros* (outside the city walls) of St. Sebastian. We have mentioned (see footnote 10) the possibility that the artist, once freed by the gendarmerie of Palo, started out on foot towards Porto Ercole, but some logical considerations bring me to an exclusion of this option. Aside from the extemporary state of health of the painter, it would have taken him much longer (and Caravaggio was in haste to get to the felucca), the roads were less safe, although the Orsini were obliged to guard and maintain the road, that by the way, was the antique consular Aurelia. This road, apart from the papal harbour Civitavecchia that was extremely dangerous to the painter, there were approximately 120 kms between Palo and the Argentario. The option of travelling on horseback was not with minor difficulties either. In any case travelling via land, Caravaggio would have had to cross various borders: besides the one belonging to the Church, the others from the dukedoms of Castro and Tuscany, until the state of the Spanish Presidi. Hence the deduction that along the only possible road over land, the Aurelia, there were various customs in entrance and exit: between the State of the Church, and the Dukedom of Castro, two between this one and Tuscany and the State of the Spanish Presidi in the Argentario, for a total of six custom offices where to pay transit-duties. So

the travel overseas must have been an almost obligatory choice (with or without the help of the Orsini). I thank Architect G. La Fauci for the useful exchange of opinions.

10 The proof of the posting of a bail can be found in one of the five letters that traveled between the Papal Nuncio, Deodato Gentile, and the Nephew-Cardinal Scipione Borghese: (29th of July, 1610) '[...] the poor Caravaggio did not die in Procida, but in Porto Ercole, because, when he reached that place on the way to Palo, he was put under arrest by the local captain. The felucca he was traveling on sailed back to Naples. Caravaggio, still under arrest, posted a handsome bail and, over land, possibly even on foot, he reached Porto Ercole, where he finally passed away. The felucca brought his earthly belongings to the house of the lady Marchioness of Caravaggio [...]' (cfr. Pacelli, *cit.*, 1994 p. 121 and: Marini, *cit..*, 2005, p. 102). The summary of events is imprecise, yet several bits of information, once put in the context, give us a rough but fairly accurate sequence of events. Details such as the payment of the bail must be accurate, because they would not have been reported if they were not, obviously, an official procedure, but rather a bribe to the local military commander (which would never have been mentioned).

11 See note 9.

12 See note 9.

correspondence, this time between the Compagnia della Santa Croce (Order of the Holy Cross), the new Viceroy of Naples (Count of Lemos), and the Prior of Capua, Dean of the Knights Hospitallers in Naples (Caravaggio had identified himself in the hospital as a member of this order), confirms the presence of the painting aboard the felucca.

Once it is established that Caravaggio is not a member of the Hospitallers anymore, having been expelled from the Order, and that his belongings are therefore not reverting to Malta, the Viceroy orders to immediately send all his belongings to him personally, in a letter dated 19th of August, 1610.

Auditor de los Presidios de Toscana. Mag.co Senor, Estoy informado q. en Puerto Hercules es muerto Miguel Angelo de Caravaccio, Pintor, y q. en vro. Poder ha quedado toda su hazienda, particolarmente la que va en Inventario q. serà con esta, por haver hecho espolio d'ella so pretesto q. fuesse del habito de St. Juan, y que tocasse al Prior de Capua, q. ha declarado non tener derecho en este espolio por no ser el defuncto cavallero de Malta, y assi os encargo q. en recibiendo esta, me embieys la dicha ropa con la primera comodidad q. se cfrecierà de Faluca, y en particular el quadro de St. Juan Bautista, y si por suerte se huviesse hecho exito del. o quitadose de la ropa de qualquier suerte, procureys en todas maneras que se halle y cobre para embiarlo bien acondicionado con la demas ropa para entegarla aqui e quien tocare y executares esto sin replica, avisandome del recibo d'esta. Nuestro Escritorio. De Napoles. a 19 de Agosto 1610.

To the representative of the State of Presidi of Tuscany
 Distinguished sir,
 I've been informed that in Porto Ercole has died the painter Michelangelo da Caravaggio. All his belongings have been kept in your custody, particularly what is included in the inventory of his possessions. They were confiscated because they were claimed to be the property of the Order of Malta, headed by the Prior of Capua. He has however declared that he has no rights because the deceased is not a Knight of the Order of Malta. On receiving this letter, please send me the items as soon as possible with the first available felucca, in particular the painting of John the Baptist if you have it in your possession. If you don't have it, try to find it with all means and I charge you to send it to us, properly wrapped, with the rest of the belongings, without any discussion. Please confirm the reception of this letter.
 From our secretariat, Naples, August 19, 1610[13]

The *John the Baptist seated* was however not in Porto Ercole anymore. The painting, along with all other belongings of Caravaggio had been brought back to Naples already, but delivered to Costanza Sforza Colonna, Marchioness of Caravaggio, who had given hospitality to the painter (and where he planned to return).[14] Both the Papal Nuncio and the Count of Lemos tried to seize the painter's works hanging in Cellamare Palace, in the residence of the Marchioness in Chiaja, where she was guest of her nephew, Luigi Carafa Colonna. The paintings subject to this attempt are described as 'the two *John the Baptist* and one *Magdalen*'. The Nuncio goes as far as to guarantee personally that the lot, well preserved and cared for, will be delivered to 'his Eminence' the Cardinal Borghese. The same claim is laid by the Viceroy, who's claim rests on Caravaggio being a Spanish subject. Both claims will however fail to

13 Cfr. H. Green, D. Mahon, 'Caravaggio's Death: A New Document', in *The Burlington Magazine*, June, 1951, pp. 202-204 (see also Marini, *cit.*, 2005, pp. 104; 128 (note 577); p. 570, n. 109, G.
14 See note 3.

yield. *The Mary Magdalen in ecstasy* is a personal gift from the painter to the Marchioness, in appreciation for the refuge she gave him during his days of absconding and recovery from injury, in the Colonna fiefdoms, specifically in Paliano.

The painting was therefore legally hers to keep. A clear ownership existed also for the *John the Baptist seated*, commissioned by Borghese and therefore to be delivered to him. On this matter, documentation exists outlining the vain attempt by the Viceroy to retain the John the Baptist, the existence of which was brought to his attention by the stock list of the painter's belongings, taken by the Order of the Santa Croce following his passing in Porto Ercole.[15] The list was of course drawn up by the Order to secure proper handling of all the belongings of the painter, in particular the *John the Baptist*.[16] The Viceroy however will only have a short time to have a copy of it made before handing it over to the Cardinal, managing however to secure the 'other' *John the Baptist*, to be found in Cellamare Palace, as mentioned by Gentili.

When in 1977 I resolved that there was a serious possibility for the painting that I had been given to examine in Germany to actually be the missing *John the Baptist reclining*, I managed to convince the owners to involve the late professor Pico Cellini, universally acclaimed as the highest authority in the technique of Caravaggio, and therefore restorer of his entire opus. When the painting reached the Cellini Studio in Rome, many of the most qualified experts were given a chance to examine it during restoration; involving names such as F. Zeri, G. Briganti, A. Giuliano, M. Stoughton, J. Spike etc, all of whom agreed on the legitimacy of the paternity claim, just as had transpired (together with a number of further conservation issues until then hidden under the surface) during the initial cleaning of the painting. The report on the restoration performed by Cellini is dated 1978 and has since been a source for my further publications on the subject.[17]

For as much as its conservation is concerned the set up is difficult to read. The use of black tar in the primer mix, as used in both Caravaggio's Sicilian paintings and two Borghese paintings (roughly dating from the same period, the *David and Goliath* (fig. 11),[18] and the *John the Baptist seated* (fig. 8)[19] 1610, allowed to paint the surface at a quicker pace, because it dried rapidly. However, this particular pigment, over time, has caused a degree of irreversible blackening of the paint. The head of the figure of the Baptist also offered three different alternatives; the artist 'changing his mind halfway through the painting' means that not even the use of radiography could tell us which one of the three visible positions of the head was the definitive version the painter confirmed on the final surface.[20]

Only an accurate examination of the colour residues in the profile, once magnified intensely, has confirmed which one of the three must have been the version the artist finally settled on, allowing for a non-invasive restoration on the face. Further 'changes of mind' confirming it could not be a copy (it's technically impossible for a copy to convincingly portray changes a painter operates in mid-production), were visible on the chest: a veal-skin had been sketched (it's 'fluffy texture' clearly visible through x-ray) and removed; the right hand has further alterations, such as in the index finger, gently lifted to point at the Messiah, who is beyond the field of view etc. Many more alterations have been pointed out under the glare of x-ray imaging and reflectographic examination subsequently performed by M. Seracini

15 Cfr. Pacelli, *cit.*, 1994, p. 121; see also: Marini, *cit.*, 2005, p. 102.

16 see note 13.

17 Cfr. P. Cellini, in M. Marini, *Michael Angelus Caravaggio romanus – rassegna degli studi e proposte,* Studi barocchi, nr. 1, Roma, 1979, p. 41 (see also Marini, *cit.*, 2005, nr. 111, p. 575, E, with previous bibliography).

18 Cfr. Marini, *cit.*, 2005, D. 108, pp. 344-345; 567-568.

19 Cfr. *Ibidem,* 2005, n. 109, pp. 346-347; 569-570.

20 Cfr. Marini, *cit.*, 1979, p. 61, Pic. 17.

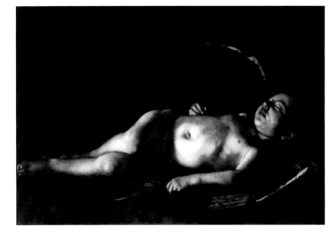

27 Caravaggio, *Sleeping Cupid*,
1608, Florence, Galleria Palatina

(Editech, Florence 1989, as per request of the new owners)[21] and the subsequent review performed by R. Lapucci, reported on by V. Pacelli and myself in the subsequent essays.[22] This final review aimed primarily to establish a link between these results and other known analysis performed on other 'southern' works by Caravaggio (*Sleeping Cupid* (fig. 27), Palatine Gallery, Florence; the *Madonna of the Rosary* (fig. 23), Vienna; *The Flagellation of Christ*, stored in the Capodimonte museum, Naples) Dr. Lapucci also observed how in the *John the Baptist reclining* (fig. 22) 'the face of the saint, drawn in penumbra [...] almost vanishes in x-ray imaging. The same happens with the face of Christ in *The Raising of Lazarus* (fig. 19) in Messina, the head of David in *David and Goliath* in the Prado, the head of the shepherd to the left of the *Nativity* in Palermo [...]'. And further technical and chemical reports by her find more elements 'typical to Caravaggio', describing how 'the strokes defining the shoulders carry on several centimeters under the head of the saint, obvious sign that the painter was not following a drawing indicating where the face would be, but was rather creating directly as he applied the colours to the canvas.'[23] The analysis of the pigments, performed during the restoration of *The Martyrdom of Ursula* (fig. 12), painted just ahead of the *John the Baptist reclining* (1610 prior to 11 of May the first, prior to 18 of July the latter), have highlighted the presence of the so called 'Naples yellow', (or 'giallorino'),[24] which is present in the *John the Baptist reclining* as well as in *Januarius beheaded* (fig. 28) (Palestrina, Museo Diocesano). This again confirms the use of an identical choice of materials for pigments and basic paint, a mixture rarely used in painting at the time.

The new papers quoting the 'two *John the Baptist* and the *Magdalen*' brought forth by Vincenzo Pacelli gave some indication of the various steps that brought the painting back to surface in Germany in the 1930's. The various transfers of property following an Argentinean lady who married into a German family and their heirs subsequently selling off the painting. Even though it is always uncertain business to attribute a painting to it's author, there are tools and elements that can give us a degree of confidence, although the only element of certainty is the painting itself and what can be gleaned from it. This is especially true in the case of this *John the Baptist reclining*, final work by Caravaggio. Following the row over the belongings of the artist between, as previously mentioned, the Count of Lemos, Viceroy of Naples,

28 Caravaggio, *Januarius beheaded*,
Palestrina, Museo Diocesano

21 Cfr. Marini, *cit.*, 2005, n. 111, E, p. 575.

22 Cfr. R. Lapucci, in Pacelli, *cit.*, 1994, pp. 147-149 (see also Marini, *cit.*, 2005, with previous bibliography).

23 See note 22.

24 Cfr. D. M. Pagane (by), *Caravaggio a Napoli – dalle Opere di Misericordia alla 'Sant'Orsola trafitta' – tecnica e restauri,* Naples 2005, page 74: '[...] in the shades on the complexion, as in the background there are elements of Umbra. Occasionally, cinnabar red is veiled by the use of lacquer, such as for instance on the red drape on the saint, whereas the yellow pigment is antimony, lead and tin based, a variation of 'giallorino' (so called Naples Yellow) typical of the 17th century. Finding this particular pigment on the *Ursula* means the use of it in painting must be backdated several years'.

29 Anonymous, *John the Baptist reclining* (copy after Caravaggio), c. 1610, Malta, private collection

and Scipione Cardinal Borghese, it is very likely that the former had to revert property of the *John the Baptist seated* to the Cardinal, but has nevertheless been able to secure the *John the Baptist reclining* instead (probably unfinished and therefore of less value according to the aesthetic sensibility of the time) of which the ownership was much less clearly defined.

Pedro Fernandez de Castro, vII Count of Lemos, reaches Naples on the 13th of July in 1610, and returns to Madrid in 1616. Here, on April the 19th in 1622, he dies, leaving the *John the Baptist reclining* to his still living mother. She in her turn bequeaths it to her younger son, Francisco, who holds the title of vIII Count of Lemos. This transfer is confirmed even though the painting is not listed in the stock list of the lady's belongings taken at her passing (in Madrid, on the 29th of February 1628), as this is the same fate of several other paintings once belonged to Don Pedro.[25] In 1629 Francisco joins the Benedictine order, with the name of Brother Augustin de Castro, ultimately passing in 1637. By 1629 however, his namesake son has already taken up the title, becoming IX Count of Lemos. He was born in Rome in 1613 and died in Madrid in 1682, after holding the post of Viceroy of Aragona and Sardinia. The x Count of Lemos is his son and heir, Don Pedro Antonio (born in Monforte of Lemos in 1632 and died in Lima in 1672). As Viceroy of Peru, he is undoubtedly responsible for bringing the *John the Baptist* in Latin America.[26] It's likely that by the 1920's, the painting is in the private collection of a Salvadoran diplomat in Buenos Aires, and is then bequeathed to the mentioned Argentinean lady, who moves to Bavaria prior to World War 2. During the war, the painting, together with other family possessions, is held in Switzerland.[27]

Copies held in private collections in Naples and Spain aside, a 'new' copy has recently been found (fig. 29), identical and coeval to the *John the Baptist reclining*; a copy of clear Neapolitan origin, dating from the first decades of 1600. The painting is ev-

25 The details on the painting have been brought to my attention by the late G. Thönn from Munich, (1976).

26 Cfr. *Diccionario Historia de España – Desde sus origines hasta el fin del reinado de Alfonso xIII*, t. II, I-z y apendices; Revista de Occidente, C/Barbara de Graganza, 12, Madrid; Gran Enciclopedia rialp, t. xIv, Languedo, Mannheim, 1973 (See also Marini, *cit.*, 2005, n. III, A, p. 574).

27 See note 25.

idently a good quality copy (for instance, is no visible trace of 'changes of mind' (*pentimenti*) from the artist, not even under x-ray examination). Indirectly, this ads confirmation to the authenticity of the archetype. Said copy, belonging to a private collector in Maine, has been sold online to a Maltese scholar. He in turn, has reported it to me, for which I thank him, adding photographic material to the report. The painting has been examined by Maltese scholars and two restorers in Rome, all of whom confirm it's antiquity and it's relation to the original, as a direct copy of it (the iconography is comprehensively reproduced).

Further copies, more or less altered, had already been reported by myself and Vincenzo Pacelli. I remember a *Lawrence* in L'Aquila, and an incision portraying a *John the Baptist reclining*, both crafted by Battistello Caracciolo.[28] Also, a *David reclining* in Naples,[29] and to prove the presence of the original in Spain, a small *Baptist* of similar design, by Juan Bautista Mayno.[30]

However, the 'new' copy is the only one found, so far, that attempts to be a nearly identical copy of the original. The comparison of this copy and the original gives us a wealth of technical data a that can be used to confirm that the *John the Baptist reclining* really does date back to the right timeline.

Compared to the original painting, the copy is of almost identical size (110 x 177 cm). On the right side, it sports a more recent vertical addition. The *status* of preservation, as of yet untouched by restoration, shows failing of the pigmentation, almost at the center, on the bottom, on the canvas just below the right arm, at the base of the right shoulder, on his right ankle and yet more, along the belt on the added element. A closer look shows, just like in the original painting, the foliage on the inside of the stone background and, faded into dark shadow, the cross of cane, symbol of the *Agnus Dei*. As already mentioned, even the highest enhancement of the x-rays does not show any trace of 'change of heart' by the painter, and there cannot be any, because indeed this is a copy.

Furthermore, in the beginning stages of creation, the copy of the *John the Baptist reclining* seems to emulate the *John the Baptist seated* rather than the painting it's copying, the latter being the painting of which the Count of Lemos had commissioned a copy once it became clear he could not keep the original.

This copy of the 'seated' Baptist, was possibly crafted by Battistello Caracciolo, and placed on the right-side altar in the Neapolitan church called 'della Scorziata'.[31] Having obtained the *John the Baptist reclining*, then still in hands of the Marchioness of Caravaggio, the Viceroy, yet again, must have requested a copy to be made, to leave in Naples, or maybe he has simply agreed on this, possibly spurred on by the Neapolitan artists, who wanted to hold on somehow to the last work by the leader of their artistic movement.

The copy however shares enough features and conceptual details with the original to prove it's strong link with it. It too is left unfinished. The foreground is largely out of focus, as is the rocky background. The patch of twilight sky is missing from the right-hand side, and the definition of the cross is imprecise, as it's largely absorbed by the base paint. On the other hand, some better preserved features seal the deal in terms of linking the two paintings, and help us to recreate elements that have faded over time in the original, such as for example the shadow veiling the upper left thigh of the youth, who visibly reminds us of the same model who posed for other paintings by Caravaggio, dating from the same years. The same young man

60

28 See note 7.
29 Cfr. Pacelli, *cit.,* 1994, page 155, pic. 67 (2nd ed. in Idem, *L'ultimo Caravaggio, 1606-1610. Il giallo della morte: omicidio di stato,* Todi 2002, p. 155, pic. 67; the conclusions there reported differ from the results of this text and my previous studies).
30 Cfr. A. E. Pèrez Sànchez, 'Caravaggio y los caravagistas en la pintura española', in various authors, *Caravaggio e i caravaggeschi,* convention papers, Rome 12-14 Feb., 1973, Accademia Nazionale dei Lincei, notes 205, p. 68, Pic. 5.
31 The painting has been stolen a few years ago. One can observe it's reproduction in Marini, *cit.,* 2005, n. 346, n. 109.

models for *John the Baptist seated*, which shares the same detail of the foot and the *David and Goliath* (fig. 11). Both paintings hang in the Borghese gallery in Rome. Further elements better preserved in the copy: the leather trousers, covered in white cloth, absorbed by the 'black tar pigment' in the original (pigment, I once more point out, commonly used in the both in the *John the Baptist seated*, the *Beheaded Januarius*, and in *The Martyrdom of Ursula*); the head of the saint, emerging from the shadows of the background confirms the validity of the choice made by Cellini in his restoration. You will remember that during the restoration there had been considerable difficulty in establishing which of the three positions of the head the definitive choice of the painter had been.

Truly the *facies* of the shadow-encased profile in the copy is perfectly identical to the final product of the restoration, solution decided upon through the analysis of the pigment remains.

Several details had remained visible on the copy (nose, lips, cheekbones and ear) and are now very similar to the Cellini restoration on the original. The copy retains some detail of the hair, which has been 'suggested' by a 'comprehensive veiling' during restoration, giving it virtually the same look as in the copy.

This painting certifies as authentic the *John the Baptist reclining* in a private collection in Munich; it's good quality, limited to the skill of the copyist (possibly the Neapolitan Carlo Sellitto), at any rate a painter at his first approach to the naturalism, the chiaroscuro and dramatic flair of Caravaggio, of which he attempted to retain the memory of his last piece influenced by the Neapolitan *humus*.

In *John the Baptist reclining* (fig. 22), his final unfinished masterpiece, Caravaggio confesses and hopes for redemption. His identity as a painter is complete and shaped in the form of a prayer, intimate and introverted. The 'auto-da-fè' of a murderer who finds himself guilty and condemned: the light (good) is at one's shoulders, and the Redeemer is yet out of sight, far away. The prayer, chocked and 'unfinished' like the painting, almost a visual lump in the throat, intercedes with the Forerunner.

Caravaggio, *John the Baptist reclining.*
Notes on painting technique

Carlo Giantomassi & Donatella Zari

This technical analysis is based on first hand observation of the painting, on x-rays and reflectographies performed by Maurizio Seracini (Editech) in 1990, on the report by Roberta Lapucci in 1991, on the restoration notes by Pico Cellini in 1977, on the observations by illustrious experts beginning with Maurizio Marini[1] and on the comparison between the techniques in two Caravaggio paintings: *John the Baptist seated* at the Galleria Borghese and *The Martyrdom of Ursula* belonging to Banca Intesa (fig. 41), as restored by us, both paintings being examples of the latest production by Caravaggio.

We have not performed further analysis in recent years, as we believe this could be done better during the upcoming restoration. After cleaning the painting it is possible to distinguish with absolute certainty the original work from the later interventions, thereby allowing for a more precise analysis of the original technique.

The original canvas consists of a single piece of fabric, plain-woven, with a density of approx. 9 x 10 threads per square centimeter. The thread is not twisted very much, is patched in places and shows localized swellings caused by the spindle.

The paint has been put on the canvas when it was already placed on a frame lacking crossbeams.

Similarly to the other two paintings examined, the paint consists of 'brown made of natural silicates and carbonates (calcite), with iron-and-umber-rich bioclasts';[2] the Borghese *John the Baptist* is ochre based (rich in silicates) and natural clay, permeated by calcite; the *Ursula* base consisting of natural clay, ochres and calcite crystals.[3]

It has long since been established that Caravaggio was in the habit of adding components to his paints, in order to give them more substance, a rougher feel and to diminish the reflecting properties of the painting: such components go from sand in the *Fortune Teller* in Rome, to the copper-based pigments in his Roman period, and the carbon granules in his Maltese days. His last works include calcite granules, sometimes of substantial dimensions.

Another trait of the painter's work of this period is the use of a restricted selection of colours, including white lead, carbon black, yellow and red ochres, umber, terre-verte, malachite, some light blue (mostly azurite-based); moreover he uses cinnabar, red lacquer, litharge, and chrome yellow ('giallorino'). More importantly, an antimony-based yellow (a.k.a. Naples yellow), identifiable on four separate areas

1 M. Marini, *Caravaggio*, Newton & Compton Editori, Roma, 3rd print 2001, pp. 574, 575. V. Pacelli, *L'ultimo Caravaggio*, Ediart, Todi 2002, pp. 147-154. M. Marini, 'San Juan Bautista del Caravaggio e la sua copia', in *Da Caravaggio ai Caravaggeschi* by M. Calvesi and A. Zuccari , CAM editrice, Roma 2009, pp. 255-267.

2 These informations are to be found in a technical report by M. Seracini on behalf of the Procura della Repubblica (the public prosecutor) at the courthouse in Rome, 10-01-2005, p. 58.

3 The research on these two paintings has been performer by EMMEBICI Studio Associato, M. Cardinali – M.B. De Ruggieri – C. Falcucci Roma; the *Ursula*, partially published in *L'ultimo Caravaggio il martirio di Sant'Orsola, Il Restauro* by D.M. Pagano, Banca Intesa Mondadori Electa s.p.a., Milano 2004, pp. 107-111.

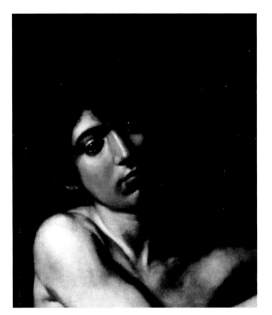

30 Caravaggio, *John the Baptist seated*, 1610, Rome, Galleria Borghese. Detail of the face and the collar bone.

31 Caravaggio, *John the Baptist reclining*, 1610. Picture with grazing light, inclusive same details of the previous picture, shows that the same model has been used, also with the presence of a kind of deformation of the collar bone similar to the one of the John the Baptist seated.

of the *Ursula* painting, which are impossible to ascribe to subsequent touching up of the painting.

The presence of this last pigment,[4] which is thought to have been introduced only after 1630, has muddled the water on several occasions, as it has also been found in the decorations of the Raphael Loggia in Villa Farnesina, painted by *Giovanni da Udine* more than a century earlier.

Moreover, several authors call Naples yellow 'giallorino', not only because the two colours are often very similar, but also because the different chemical structure is the merely result of impurities occurring in the same base components.

Recently a process of backdating the use of antimony yellow has begun, and it seems likely that further specific examination will allow for a deeper understanding of this color (which only recently has been put under close scrutiny), in order to derive a more accurate timeline for it's use in painting.

The presence of this color in both paintings proves their common 'age', and since we have written documentation citing the exact date of delivery of the *Ursula*, 11th of May 1610, it's almost certain that, before his last voyage, Caravaggio painted the *John the Baptist reclining*, possibly to donate the pair to Cardinal Scipione Borghese, in order to secure a papal pardon by intercession of the latter, who was nephew to Pope Paul V. There's however another possibility, namely that this final John the Baptist was in fact destined to Marco Antonio Doria.[5]

The original colour is often exposed to the surface and, conservation issues and Cellini restoration induced patina aside, it's very noticeable how, not unlike in most of the other production by this painter, the paint itself rises to the role of fundamental structural element of the chromatic composition.

X-rays examination is able to bring forward the underlying structure of the com-

4 For details on the use of chrome yellow and Naples yellow, see Cennino Cennini, *Il Libro dell'-Arte*, Neri Pozza Editore, Vicenza 1971, pp. 48, 49; G. Montagna, *I Pigmenti,* Nardini Editore, Firenze 1993, sheets nr 69 and 70; *L'ultimo Caravaggio il martirio di Sant'Orsola*, cit., note 3 p. 111.

5 To explore the different hypothesis concerning the destination of the painting, see V. Pacelli , *L'ultimo Caravaggio, cit.*, pp. 151, 152 and M. Marini, *San Juan Bautista del Caravaggio e la sua copia, cit.*, p. 256.

32 Caravaggio, *John the Baptist seated*. Detail of the hands. (Picture Polo Museale Romano)

33 Caravaggio, *John the Baptist reclining*. Detail of the hands, similar to those of the previous picture, with the extremely elongated fingers, there are also *pentimenti* to be noticed that involve the fingers of both hands.

34 Caravaggio, *John the Baptist seated*. Detail of the right foot. (Picture Polo Museale Romano)

35 Caravaggio, *John the Baptist reclining*. Detail of the right foot that results to be completely similar to the Borghese one, particularly long. Grass blades painted on the red cloak as well as small flowers at the back can be noticed.

position, as well as the progression of the painting, using light to focus all attention on the shoulder, the right arm, and the tangle of red depicting the cloak.

Typical of Caravaggio are the progressive repositioning of the figure (i.e. the left arm, as correctly noted by Marini) and the adjustments, the knucklebones of the left hand have been extended. It's impossible not to notice the strong similarity between

36 Caravaggio, *John the Baptist seated*. Detail with small flowers and grass.
(Picture Polo Museale Romano)

37 Caravaggio, *John the Baptist seated*.
Detail of the cinnabar red cloak. (Picture
Polo Museale Romano)

38 Caravaggio, *John the Baptist reclining*. Detail of the cinnabar red cloak; observe the
total similarity of the pictorial set-up to the Borghese picture.

these hands and those of the Borghese John the Baptist, with their long fingers, al-
most unnaturally so; impossible not to see that the shoulder (where possibly the
painter has had a change of heart after initially projecting in it's place a fold of the
lambskin) is sporting the same peculiar contortion present in the painting of the
Borghese gallery. Even the pointed knee, and the extremely elongated right foot (fig.
30-35) seem very consistent with that other John the Baptist. The facial structure is
visibly that of the same model who posed for the Borghese painting, and who else

39 Caravaggio, *John the Baptist seated*. Reflectography I.R. allows to see into the pictorial layers, under the paint and the retouching of the restoration. (Picture Polo Museale Romano)

40 Caravaggio, *John the Baptist reclining*. Reflectography I.R., it is interesting to observe how the pictorial set up of both paintings is extremely alike, even though the reflectographies have been done by different people using different machinery.

but Caravaggio could have painted, probably from recollection, the same model, using the same paint, which we know to be in itself quite uncommon?

Again, in positioning the head, the artist has made several changes and adjustments, just like with the red cloak, where an elongation and enlargement on the right-hand corner is visible to the naked eye (fig. 36-38).

In the composition there is no evidence of an outline or preparatory drawing, nor can the reflectographies find trace of anything of the sort, and again, this is true for every other painting by the same artist we have performed the restoration of. On the other hand, Cellini reports an incision on the head of the saint. To be truthful, we cannot vouch for this, possibly because the paint and the subsequent restorations have made this impossible to establish for certain (fig. 39-40). One would however remark that in his final years, the painter was not in the habit of using incisions.

As has correctly been pointed out in the essay on the *Ursula* 'in the evolution of the late Caravaggio towards an extreme synthesis of those painting processes Caravaggio had been refining ever since the end of the 16th century, the *Ursula* painting confirms a tendency to briefly outline only the focal points of the painting, and the use of the paint in a chromatic role'[6] and this is exactly how the face of St. John was put on canvas, almost non-existent, not because of decay or conservation issues, but because it is hidden from the light.

Further analogies with the Borghese painting are the stone wall, that is background to both of the characters, the presence of sparse patches of vegetation in the foreground, but more importantly, a handful of flowers in the reclined John the Baptists resemble the flowers in the Borghese painting, and, in Marini's words 'are testimony, in Caravaggio, of a never diminished love for nature'.

In terms of layering of the paint, one has already hinted at how the focal 'lights' of the painting are worked on at the same time, applied to the dark hue of the

6 *L'ultimo Caravaggio il martirio di Sant'Orsola, cit.,* p. 108.

groundlayer. Those focal elements are always neatly detached from one another, the base they rest upon sometimes veiled by darker shades. At any rate, from the very beginning of this work, the painter anticipates the chiaroscuro, and here too is yet another proof of similarity with what has already been written about *Ursula* 'from the very first draft, the painter anticipates the position and flow of the chiaroscuro, which is confirmed by x-ray examination.'[7] It suffices to examine the x-rays of the *John the Baptist reclining*, to understand the profound accuracy and similarity of that statement.

The fluid and strong execution of the complexions uses sparse and well defined light colors, and they appear exceedingly soft; but this is quite possibly due to the skillful veiling and application of color applied by Cellini who preferred to tone down the rough brushstrokes by Caravaggio. The strength and abruptness of the brushstroke is more perceptible in the hands, which have seen less restoration than other parts. The same applies to the masterful red cloak, which appears a bit too smooth, as if just ironed. On the rocky background instead, where the restorer has not intervened quite as much, a hovel of obscure beauty offers itself to us, streaked with crevasses and sparse hints of vegetation.

Finally, some observations.

The painting, presenting traces of a number of *pestimenti* by the painter, cannot be a copy, which is confirmed by the near identity with the materials used in the other two paintings we analyzed.

If this painting could not have been painted prior to 1630 as argued by some, in light of the use of antimony yellow (variation of chrome yellow, or Naples yellow), how could this alleged copy-cat have perused the services of the same model, a young man, used for the Borghese painting a good 20 years prior?

He would be well over 40 by then!

Recently, Marini has exposed a similar version, currently traded from Malta to the USA, whereof, lack of *pentimenti* aside, it is self evident beyond doubt, that it cannot be a genuine article.[8]

All of the above mentioned elements concur to the same conclusion, namely that the privately owned *John the Baptist reclining* must be a genuine painting by Merisi, that it is part of his last Neapolitan period, and that it is most likely to be the painting of the same subject, missing from the felucca boarded by the painter, headed for Rome.

PRESERVATION STATUS

The painting, restored by Pico Cellini in 1977-78, is in fairly good preservation status. The lining is still perfectly serviceable, and the frame is giving an appropriate amount of strain to the canvas. One notices a slight slacking of the canvas, which can be addressed by adjusting the strain on the frame itself. Along the rims, very small flaws are visible, attributable to improper handling. The paint seems to be well attached to the canvas overall, and one doesn't notice detachments or flaking of the paint.

The colour appears however tarnished by a widespread alteration of the paint itself.

41 Caravaggio, *Martyrdom of Saint Ursula*, (detail), 1610, Naples, Intesa Bank. Retail of the pentimento above the head of Saint Ursula, where the yellow pigment results to be antimony based, which cannot be attributed to later interventions because in the past it had been covered by a black repaint. (Picture Intesa Bank)

7 See previous footnote.
8 M. Marini, *San Juan Bautista del Caravaggio e la sua copia, cit.*; pp. 255-267.

The entirety of the contour (for approx. 3 cm from the rim) has been retouched appropriately, and u v observation highlights numerous retouches, some of them altered and, more importantly, many semi-transparent patinas often extended so as to cover large areas of the painting. Also, some of the contour lines have been reinforced, giving an opening for speculations about possible incisions.

Cellini was a masterful restorer, and possessed a deep knowledge, operating along guidelines of his times, such as for instance the use of pigmented paint, to cover the entire surface of paintings with a patina and a veil, to 'soften' some of the rougher edges he saw, on some of the paintings, especially those by Caravaggio.

We remember how, after we restored the *Judith and Holofernes* of the National gallery in Palazzo Barberini in Rome, which Cellini himself had restored several years prior, in a friendly encounter, he remarked how, according to his criteria, the right arm of Judith was too rough and how he (Cellini, not Caravaggio) had given it a patina, thereby toning it down somewhat, whereas our removal of his work had brought a measure of imbalance to the painting. In truth, the painting was in perfect state and Caravaggio would shun veiling and soft patinas. Never, would he have lowered the edge on such a splendid sample of his craft.

The *John the Baptist* too appears to be slightly dimmed and downcast, surely because of veiling of whatever degree, which in time have further altered and faded.

One believes a renewed and careful cleaning, will bring to light the painting in a manner closer to the original artwork than it's current state allows for, giving us a renewed perspective of the painting, just as it happened with the *Ursula*, which has returned to it's status of masterpiece, despite the original paint being far more eroded and disheveled than is the case with this *John the Baptist reclining*.

Calvesi, Maurizio, *Le realtà del Caravaggio*, Turin 1990

Cinotti, Mia en Dell'Acqua, Gian Alberto, *Michelangelo Merisi detto il Caravaggio. Tutte le opere*, Bergamo 1983

Corradini, Sandro, *Caravaggio. Materiali per un processo*, Rome 1993

Ebert-Schifferer, Sybille, *Caravaggio. Sehen – Staunen – Glauben. Der Maler und sein Werk*, n.d. [2009]

Friedlaender, Walter, *Caravaggio Studies*, Princeton 1955

Graham-Dixon, Graham, *Caravaggio. A Life Sacred and Profane*, London 2010

Langdon, Helen, *Caravaggio: A Life*, London 1998

Macioce, Stefania, *Michelangelo Merisi da Caravaggio. Fonti e documenti 1532-1724*, Rome 2003

Marini, Maurizio, *Caravaggio 'pictor praestantissimus'. L'iter artistico completo di uno dei massimi rivoluzionari dell'arte di tutti i tempi,* Rome 2005

Pacelli, Vincenzo, *L'ultimo Caravaggio. Dalla Maddalena a mezza figura ai due san Giovanni 1606-1610*, Todi 1994

Papa, Rodolfo*, Lo stupore dell'arte*, Venice 2009

Spike, John T., *Caravaggio (second revised edition)*, New York, London 2010

Treffers, Bert, *Caravaggio. Genie in opdracht. Een kunstenaar en zijn opdrachtgevers in het Rome van rond 1600*, Nijmegen 1991

Treffers, Bert, *Caravaggio – Nel sangue del Battista*, Rome 2000

Treffers, Bert, *Caravaggio. Die Bekehrung des Künstlers*, Amsterdam 2002

Vodret, Rossella, *Caravaggio. L'opera completa*, Cinisello Balsamo, Milan 2009

Schütze, Sebastian, *Caravaggio: The complete Paintings*, Cologne 2010

Zuccari, Alessandro, *I Caravaggeschi,* Milan, 2010

Outstanding conference papers in chronological order:

Macioce, Stefania ed., *Michelangelo Merisi da Caravaggio. La vita e le Opere attraverso i Documenti. Atti del Convegno Internazionale di Studi*, Rome (1995) 1996

Calvesi, Maurizio en Volpi, Caterina eds., *Caravaggio nel IV centenario della Cappella Contarelli. Atti del Convegno Internazionale di Studi,* (Rome 2001), Rome 2002

Ebert-Schifferer, Sybille, Kliemann Julian, Von Rosen, Valeska en Sickel, Lothar, *Caravaggio e il suo ambiente. Ricerche e interpretazioni*, (Studi della Bibliotheca Hertziana 3) Cinisello Balsamo (Milan) 2007

Calvesi, Maurizio & Zuccari, Alessandro eds., *Da Caravaggio ai Caravaggeschi,* Rome 2009

Important and recent exhibition catalogues:

Danesi Squarzina, Silvia, ed., *Toccar con mano una collezione del Seicento. Caravaggio e i Giustiniani,*Rome (Palazzo Giustiniani) and Berlin (Altes Museum), 2001
Caravaggio: l'ultimo tempo 1606-1610, Napels (Museo di Capodimonte) 2005 (also London, 2005)
Strinati, Claudio, Rossella Vodret, Francesco Buranelli, *Caravaggio*, Rome (Le Scuderie) 2010

This book is published in occasion of the exhibit of The last Caravaggio
in Museum Het Rembrandthuis, Amsterdam, Netherlands, December 3,
2010 – February 13, 2011

Uitgeverij Waanders, Museum Het Rembrandthuis,
Guus van den Hout Art & Advice

The editors wish to thank Pino & Cristina Bianco, Ruben Blijdorp, Bob van den
Boogert, Claudio Metzger and Ivàn Ocampo Pérez for their genereus support in
realizing this publication

CONCEPT Bert Treffers

EDITING Bert Treffers, Guus van den Hout

TRANSLATIONS Evelyn H.S. Rosenblatt, Alessandro D. Maggiorotto

DESIGN Marjo Starink

PRINT ÈPOS|PRESS, Zwolle

ISBN 978 90 400 7794 4

www.waanders.nl, www.rembrandthuis.nl, www.guusvandenhout.com

COVER Caravaggio, *John the Baptist reclining*. Photo Ivan Baschang